Fantasy
Creatures
in clay

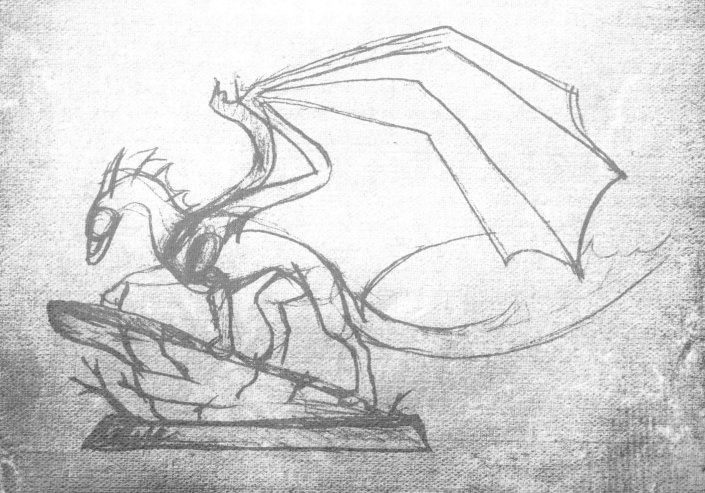

FANTASY CREATURES
in clay

TECHNIQUES FOR SCULPTING
DRAGONS, GRIFFINS
AND MORE

EMILY COLEMAN

IMPACT
CINCINNATI, OHIO
www.impact-books.com

CONTENTS

WHAT YOU NEED

MATERIALS

acrylic paints, assorted

aluminum foil

Apoxie Sculpt epoxy putty

clay: Super Sculpey, Super Sculpey Firm, Sculpey III, Premo! and/or Monster Clay

drawing paper

glassine paper

Mod Podge

Pearl Ex powder

primer paint, spray-on

sealant, brush-on or spray-on

varnishes, spray-on and clear brush-on

wire mesh, medium gauge recommended

wire, various gauges: fine, medium and heavy

wood bases

wood beads, black

TOOLS

craft knife and blades

hammer

heat gun (optional)

hot glue gun (low-temperature) and glue sticks

metal detail tool

metal or wire ribbon tool

needle tool

oven, conventional not microwave

paintbrushes, assorted including firm soft-bristled, large round-tipped and small fine-detail

pasta machine (optional)

pencil

permanent marker

pliers

rubber tools

scissors

straightedge

texture stamps (optional)

watercolor pencils

wire cutters

wooden tools (optional)

OTHER SUPPLIES

cornstarch (baby powder optional)

glue (optional)

masking tape (optional)

newspapers

palette

paper towels

reference photos and anatomy books

rubbing alcohol

sandpaper, 220 grit or finer

Super Glue or epoxy glue

U-nails

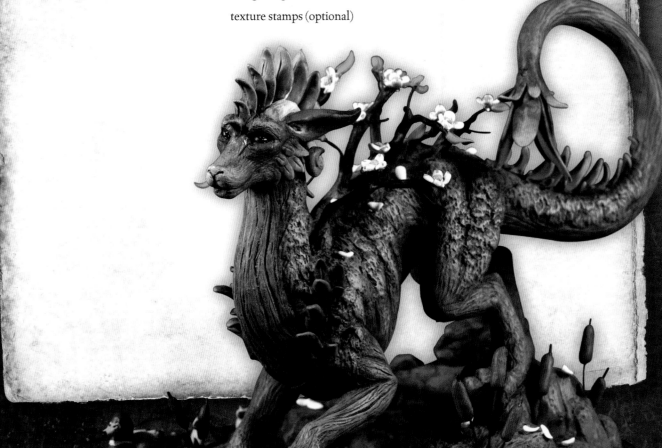

INTRODUCTION

For me, sculpture was mostly a self-taught skill. I never went to art school. I have my degree in digital media, which has very little to do with traditional hands-on art. There were only a few sculpture books on the market when I first began sculpting in 2001, and most of them were rather outdated. None of them directly applied to the field of work that I wanted to get into. I learned about where to start from Katherine Dewey's writings, namely *Creating Life-Like Animals in Polymer Clay*. I mostly referenced anatomy books, photos, pre-existing sculptures and real life. Practice, practice, practice is the main reason I've gotten to the point I am now. At the time of this writing, I've created hundreds of sculptures of varying size, complexity and subject matter.

With each sculpture, I try to learn something new. Even if it's a small step each time, I am always learning and growing. Every now and then, I like to do a piece that is completely out of my comfort zone and interest range. I will experiment with a new style or sculpt an animal I have never heard of before. After I do this, my art takes a turn in a new direction and shows great improvement.

In 2006 I began teaching at Full Sail University in Winter Park, Florida. I worked in the computer animation department and focused on traditional art. I learned a lot through teaching others for five and a half years. My former job has been a big inspiration for writing this book.

I know how difficult it is getting started in sculpture. There is a serious lack of tutorials and reference for beginning sculptors. There were points (and still are sometimes!) when I was ready to tear my hair out in frustration. This book is to help you skip that step and get right into learning your own style and methods in sculpting.

I have not written this book in a step-by-step how-to-recreate-this piece style. The reason for this is that in order to be a successful artist, you need to learn to apply techniques to your own ideas and creations. Use this book as a starting point and develop your own ideas as you go though it. Rather than recreating the pieces I have done in this book, apply the techniques demonstrated to your own works.

I will be covering all the information you need to complete a sculpture. I will start with an introduction to the materials needed, moving on to armature building and blocking out the main forms with clay. From there, I will discuss various techniques on detailing a sculpture from anatomy to texture. I will then cover painting and finishing techniques to apply to your piece.

Creating this book has been a learning process for me. I hope you also learn from it and get introduced to some new concepts and techniques.

Enjoy, and happy sculpting!

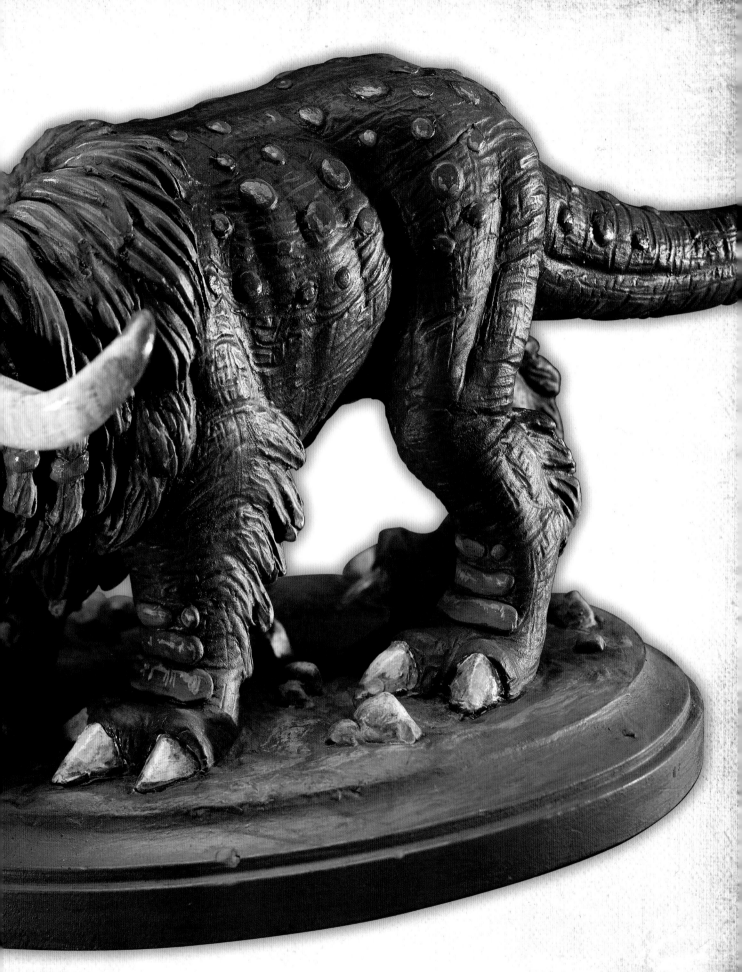

Visit **www.impact-books.com/fantasy-creatures-in-clay** for more amazing bonus features!

7

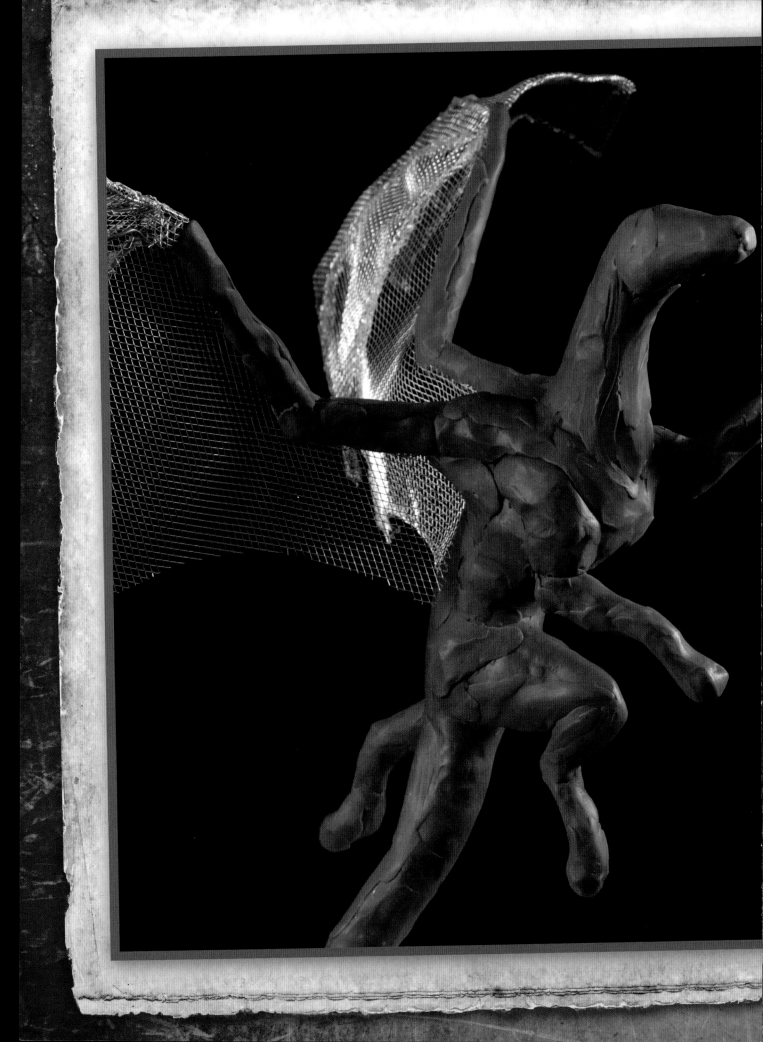

SCULPTING MEDIUMS

Many materials can be used in sculpture. When starting out, it can be a bit overwhelming. To choose the correct medium, you must first understand the proper applications of each so you can select the best one for you.

Polymer clay is soft and pliable, but will become hard and ceramic-like when baked. The plasticisers in the clay react to heat and can be baked in a home oven at a low temperature. Baked polymer clay can be sanded, carved, and painted.

Oil-based clay always remains pliable and is unable to be cured and hardened. Many of these clays are wonderful to work with, but they require molding and casting to create a finished, painted piece.

Epoxy clays are two-part molding compounds that cure when equal amounts of both parts are combined. These clays cure to a rock solid state after a workable period of several hours.

In this book, we will be using both polymer clay and oil-based clay to work with different techniques. I will also show how Epoxy clay can be used in conjunction with polymer clays. Keep in mind many of the techniques shown can be used with other clays too!

Materials and Tools

Clay

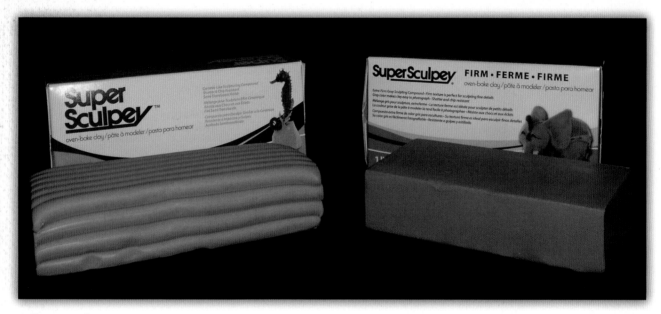

Polymer Clay

Super Sculpey is probably the most widely used polymer clay. It is pliable yet holds a high amount of detail. It is a beige/pink tone and can be tinted with inks or colored polymer clays. Super Sculpey can be purchased in one pound (454g) blocks or in bulk packages.

More recently, Super Sculpey Firm was released. It is more waxlike in consistency, but still won't harden until it is baked. This clay can hold an amazing amount of detail, as it doesn't get as soft as regular Super Sculpey. It is great for faces, textures and hard mechanical edges. It is difficult to manipulate, so doing entire sculptures with it can be monotonous. However, it can be blended with regular Super Sculpey and used only in the areas with extreme detail.

Sculpey III and Premo! come in all different colors including metallic, translucent and even glow-in-the-dark. These clays are often used in jewelry making as they can be combined to look like precious stones and metals. I use them from time to time if I want to create special effects with eyes or other small details in a sculpture. Normally though, I find it is easier to just paint the Super Sculpey after baking it.

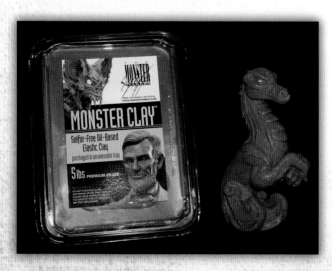

Monster Clay

In my opinion, Monster Clay is the most ideal clay on the market as far as workability is concerned. It holds detail as well as wax but has pliability closer to Sculpey. Since this clay is oil based, it can never be cured. The drawback to this is in order to create a finished and painted piece, a mold and cast need to be created from the original. Since this is time-consuming and costly, I use Monster Clay only for pieces I intend to make multiple copies of. It is also great for practicing your sculpting skills since it can be reused over and over. Monster Clay can be purchased in five pound (2.3kg) blocks directly from the manufacturer and comes in a medium-brown color.

Armatures

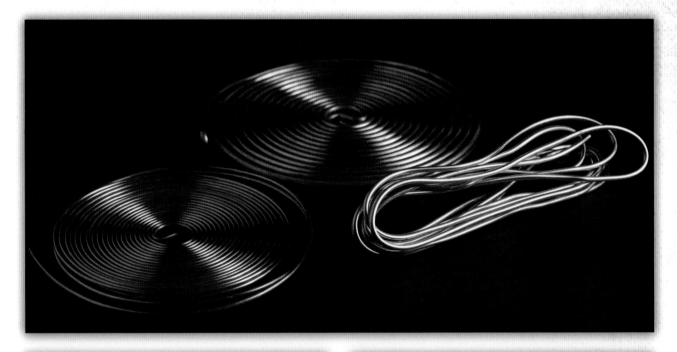

Wire, Cutters and Foil

At the core of every great sculpture is a strong and thought-out armature. I create my armatures using aluminum armature wires and household aluminum foil. Since Sculpey bakes at only 275° F (135° C), the aluminum is perfectly fine in the oven.

Aluminum armature wire can be purchased at most art stores. It is available in a variety of gauges. I normally like to have three different gauges on hand: a fine, a medium and a heavy. The smaller the gauge number, the thicker the wire. Fine gauge wire (20 or 18 gauge) is used in hands, feet, wings and in thin protrusions such as spikes and upright feathers. Medium gauge wire (16, 14 or 12 gauge) is normally used for the main structure of the body. Heavy gauge (10 gauge) is used to support a dynamic pose or as the main structure for a larger, heavier sculpture.

Be sure to have a good, sharp pair of wire cutters on hand as well as a comfortable pair of pliers to help you bend heavier gauge wire.

Aluminum foil is used to bulk out thick or heavy areas of a sculpture to keep the sculpture lightweight and to help conserve clay. Any brand will do; I tend to buy whatever is on sale.

Wire mesh is a wonderful tool for creating wings, capes and flowing fabric. It is sold in varying densities and strengths; I usually go with the medium gauge.

Visit **www.impact-books.com/fantasy-creatures-in-clay** for more amazing bonus features!

11

Materials and Tools

Sculpting Tools

I do a lot of my sculpting with my hands. However, there comes a point when sculpting tools need to be implemented. Most of these tools you can find at an art supply store or through online catalogs.

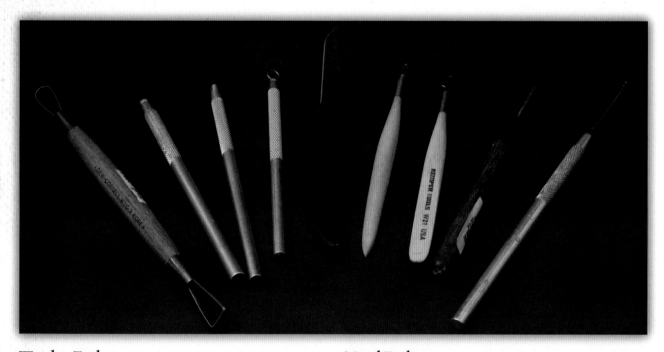

Wooden Tools

Wooden tools come in a variety of shapes. I normally use them for forming larger parts of the sculpture and getting into areas I can't reach with my hands. I don't normally use these tools for fine details and textures. You can even use a sharp knife to carve away at the wooden tool and get it the shape that you want.

Ribbon Tools

Ribbon tools are loops of metal or wire used to carve away at the clay. They work better with harder clays that have less give to them. I often use these tools during the block-out phase and to carve out eye sockets. They can also be used to create smooth surfaces by carving away at the surface of the sculpture. Very fine ribbon tools are great for creating smooth lines and fine textures.

Metal Tools

Metal tools are mostly variations of knives and needles. They are good for creating hard lines and carving away at small areas. For the most part, I stay away from these tools for texturing as they tend to create a more drawn-on look. I often use them in facial details, especially around the eyelids where a harder line is desired.

Texture Stamps

Texture stamps can be purchased or created on your own. To make a stamp, press a texture into a piece of clay and bake it. For example, try pressing clay into cement or asphalt. After baking, you can then stamp that texture into your sculpture.

Pasta Machines

Pasta machines can roll out thin, even sheets of clay that can be used to create capes, flowing clothes or wings. I've found that real pasta machines are sturdier than the ones created specifically for polymer clay. It's best to start out using the thickest setting and then go thinner from there.

Pasta machines are also great for mixing clays together. I use mine to create the $^{59}/_{50}$ mix of Super Sculpey and Sculpey Firm that makes up many of my sculptures.

Rubber Tools

Rubber tools are like a paintbrush with a rubber tip. These tips come in several different shapes, three different hardnesses and a variety of sizes. I normally stick to the smallest sizes available as well as the hardest tip, which comes in black. I probably use these the most out of all the tools. They can be used to smooth in tight areas, create flowing textures and form creases.

Materials and Tools

Bases

Wood Bases

Wood bases can be purchased at most craft stores. They come in a variety of shapes and sizes. Be sure to buy one that is unfinished since it needs to go in the oven. Bases are great to anchor a figure that wouldn't be able to balance properly standing on its own. You can also integrate an environment into a piece by using a base. Sculpey can be attached to the wood base and baked.

Nails

U-nails (or poultry net staples) are used to attach an armature to a base. The U shape anchors the wire and holds it in place. You can purchase these at any hardware store. Get the smallest size available as the larger ones are too big for most anything you will be making. Make sure to have a small hammer on hand to drive the nails into the base.

PAINTS

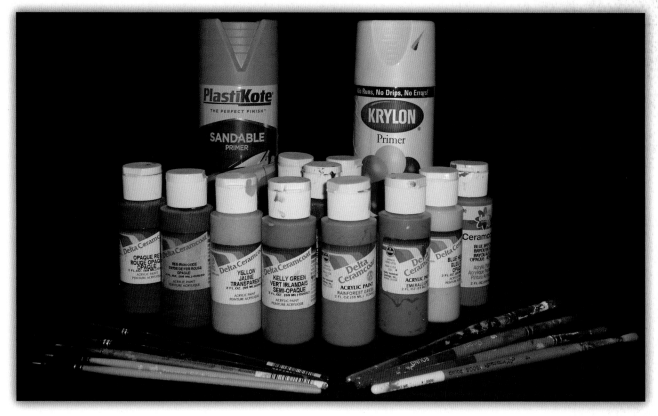

Primer

Primer comes in spray cans and can be found at art supply stores as well as hardware stores. While you can paint directly on baked Sculpey, I've found it best to first prime the piece. I normally use gray or white, depending on the overall color of my sculpture. Primer not only helps the paint adhere to the sculpture, it also fills in tiny imperfections and smooths out the surface of the piece.

Extra Coats

Matte and gloss coats are available to finish your sculpture once it is painted. They come in brush-on forms as well as spray-on. I use a matte spray coat to seal the sculpture and help prevent the paint from chipping. I then use a brush-on gloss coat for details like eyes, teeth and claws. Both Delta Ceramcoat and Sculpey make wonderful brush-on glosses.

Acrylic Paints

Acrylic paints are the best type of paint to use on Sculpey. They are water soluble and dry quickly. I prefer to use craft acrylics that come in bottles as opposed to the artist acrylics that come in tubes. The reason being the craft acrylics are thinner and dry better on baked Sculpey.

I use Delta Ceramcoat brand paints and have found them to be the best. They have just the right consistency and come in a wide range of colors including pearls and metallics. Some brands of paint tend to be a little too watery, and you have to apply many layers to get a good solid coat of paint.

Palettes

Paper palettes are available in pads and are great for keeping down the mess. I use these as well as a ceramic palette, which is easy to clean.

Brushes

Paintbrush selection is important but not difficult. I stick to artificial fibers as they are more durable and cheaper than natural fibers. You can buy sets of Taklon brushes at art supply stores; this tends to be my favorite material for brushes. It has just the right amount of give. Make sure to get a wide range of sizes with large brushes for basecoats, mid-sized brushes for the main detailing, and small brushes for fine detailing. Always wash your brushes when you are done painting and store them tip up. This will maximize the life of your brushes by preserving the shape of the bristles.

Visit **www.impact-books.com/fantasy-creatures-in-clay** for more amazing bonus features!

15

Materials and Tools

Finishing Tools

Heat Guns

Heat guns are handheld tools resembling a hair dryer. They can be used to bake small pieces such as eyes and weapons to be placed on your unbaked piece. This can be a good time-saver so you don't have to fire up your oven just to bake a few small things for several minutes.

Epoxy

Two-part epoxy putty is a great filler that dries as hard as a rock. Aves makes a compound called Apoxie Sculpt that is a quality product I always keep around the studio. Once the putty is dry, it can then be painted over. I also use it to reinforce armatures.

Rubbing Alcohol

Rubbing alcohol can be used to smooth out a sculpture before baking. It breaks down the oils in the clay and sort of melts them together. Any regular bottle of drugstore brand rubbing alcohol will do. This is a great technique for getting a polished look, especially for metal.

Isopropyl myristate works similarly to rubbing alcohol but works well on Monster Clay. A 50/50 mix of rubbing alcohol and myristate will help preserve detail. Myristate can be purchased directly from this website: monstermakers.com.

Sandpaper

Sandpaper can be used on a baked sculpture to smooth out surfaces. I normally use 220 grit; anything coarser may damage the surface of your sculpture. 3M makes wonderful Pro Grade sandpaper that has a backing with a slight tack to it. I usually keep a bunch of this cut up into small squares, ready to use at any time.

Glues

Glues are important to have on hand in case of breaks. Super Glue as well as two-part epoxy work great to fix clean breaks. They dry quickly and create a very strong bond. If the break isn't clean or if there is a visible seam, putty can be used to fill in cracks and chips. You will also need a low-temp hot glue gun to glue together pieces of armature.

Craft Knife

An craft knife is a must-have tool for any artist. This can help clean up surfaces and edges on a baked piece. Make sure you keep a reserve of new, sharp blades on hand. I tend to use X-ACTO blades, but can try out a variety of craft knives to find your preference.

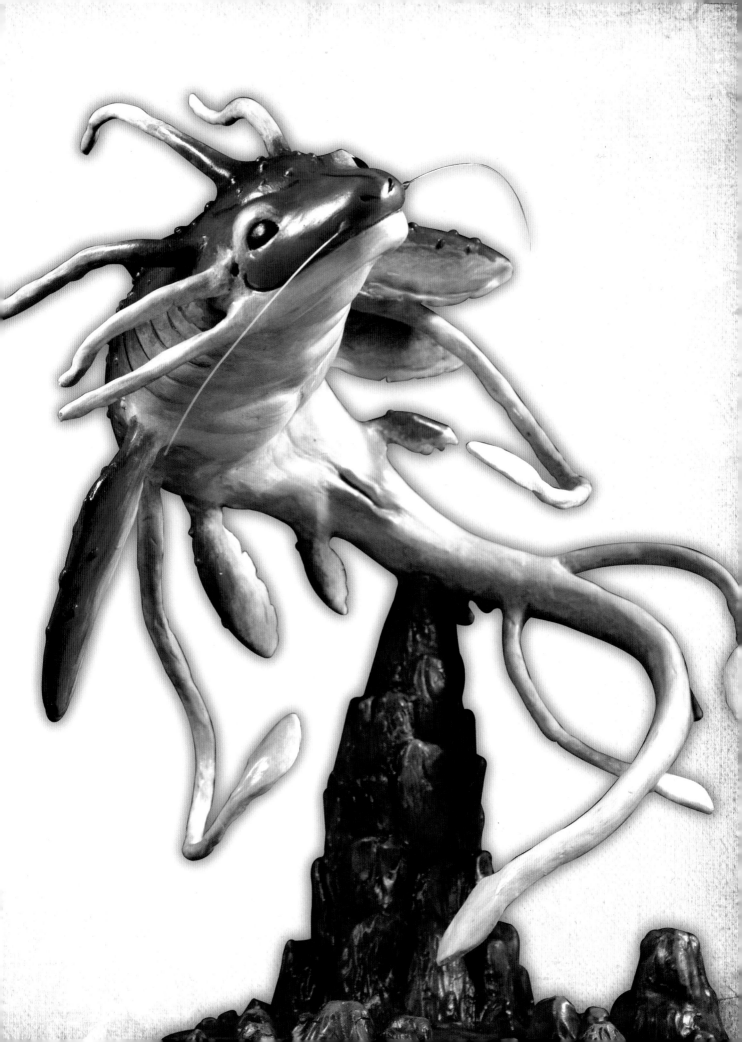

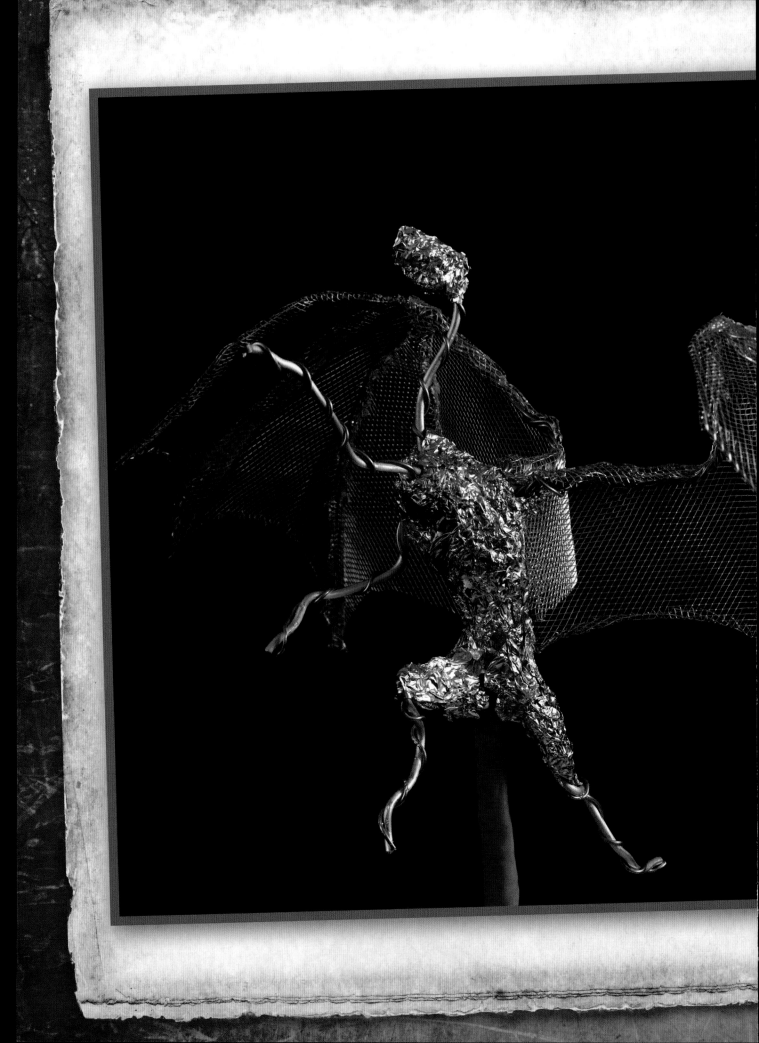

ARMATURES

As stated previously, creating a strong and proportionate armature is the key to a successful sculpture. Think of the armature as the skeleton of your sculpture. Don't worry about making it look beautiful as it's all going to be covered up in the end. You do, however, want to be concerned with creating stability and accuracy.

Take your time during this part of the sculpting process. Getting all the proportions right in this stage will make it that much easier for you once you start applying clay. Making changes to an armature once you have begun clay work is very destructive and not something you want to have to worry about. Get used to enjoying the whole process of sculpting, starting with the armature.

Armature Layout

Before even touching a lump of clay, your ideas should be put down on paper in some form. While I do sometimes start sculpting without any idea of what direction I am going, most of what I do is based on some sort of concept sketch and real-life reference material. Brainstorming, researching and concept work are all very important to do before beginning a sculpture. Look at some of the creatures and characters out there that you find most effective.

Research

Once you have decided on an idea you want to work with, it is time to begin researching. Even if you are creating a creature of fantasy, researching real-life animals and environments will make your work more realistic and believable. Collect several reference photos together with your concept sketches. Make sure you have references available for anatomy, textures and environment. Depending on your character, you may also need references for things such as weapons, costumes and vehicles. Leave no detail untouched. It is better to have a surplus of reference than to not have enough.

Sketches

Even if you feel you are starting a project with an idea you are certain you want to use, work with it a little. Change it up, do some different sketches showing different variations of the same idea. Chances are, you will come up with something you like even better than your initial idea. In the sketch pages above, I was doing just that.

CONCEPT ART

A turnaround sheet is a vital piece of concept art that shows a character from at least three different angles. You will be working directly off this to create your sculpture, so you will want to get as much detail in as possible and correctly show proportions. For the purpose of the turnaround sheet, it is best to pose the character in a neutral pose that doesn't hide any important details. You may need to remove certain details on one or more views if another detail is being obstructed. For instance, if a character is wearing a cape, you may want to leave it off on the back view so that you can show what the detail of the character looks like underneath.

It is very important to reference anatomy books to ensure that your proportions are correct. You may want to use a straightedge to measure different parts of the body and see how they compare to other parts. Draw a series of horizontal lines across your page to make sure key points of your character line up in each view. I usually line up the top and bottom of the head, the shoulders, the hips, the knees and the bottoms of the feet.

Visit **www.impact-books.com/fantasy-creatures-in-clay** for more amazing bonus features!

21

Armature Layout

Dynamic Posing

Now that you have a completed turnaround sheet, it's time to pose the character. Sketch out a few pose ideas, keeping anatomy and realism in mind. Make sure that joints are bending no farther than they would in real life. Fill in the sketches with a black marker to silhouette them. Not only should you be able to easily read what the character is doing, it should look interesting and dynamic. If none of these poses work for you, keep trying a few more until you find one that is workable. Pay close attention to the line of action. This is a single line that describes the movement of a subject. Dynamic poses have an exaggerated line of action. The more curved the line, the more dynamic the pose.

Composition

Posing and composition go hand in hand. You want to make sure that your piece is balanced and that your character flows together with its environment. Create a few sketches showing how you want to place your character in its environment. Create elements that tell a story about the character, even if they are subtle. Think about where your character may live and what it does. Is it good or evil? What is its background?

Thumbnail

Take some time to create an armature layout for you to follow as you work. This can be the front or side view from your tunaround sheet. Most any image can be used so long as it follows these parameters:

1. The character must be in a neutral pose, i.e., standing. No dynamic poses for this phase.

2. The image must be an orthographic view (straight-on view from the front, side, etc.).

3. The image must be the same size that you want your sculpture to be.

Once you have your image ready, it's time to create your armature layout.

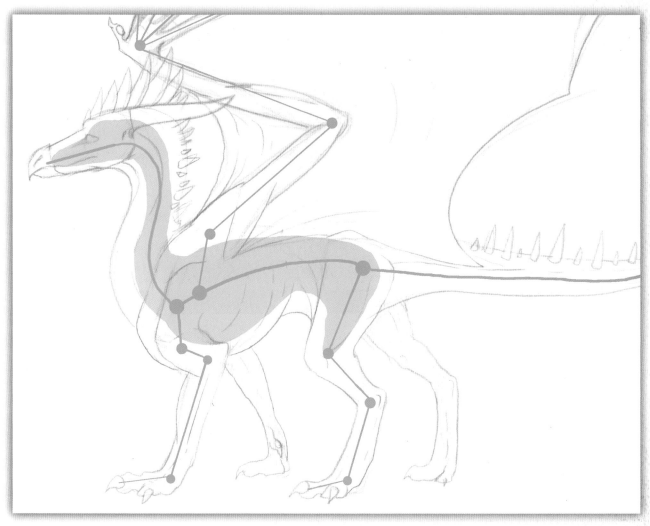

1 Map out the wire lines in the center of the limbs. This will give you room to build up clay on either side of the wire.

2 Make sure to include the hands and feet. You will need that extra length to anchor the armature to the base later on. You can add an inch (3cm) or so of extra length too, just to be on the safe side.

3 For a quadruped, you will want to map out from a side view as seen in the example here. You only need to map out one half of the limbs. You will build all four limbs off this map. For a biped, you will want to use a front view, mapping out all limbs.

4 If you want to map out foil placement, leave enough padding so you can build up ⅛–¼" (3–6mm) of clay around the whole sculpture. Foil only needs to go in bulkier areas like the torso and head. This will be explained further once we get to putting foil on the armature.

BUILDING A BASIC ARMATURE

1 Start by cutting a two yard (183cm) length of medium gauge wire and folding it evenly in half. This will be enough wire for a 5–6" (13–15cm) figure. If you are going bigger, add another yard or two. I generally allow one yard (9cm) of wire per 2–3" (5–8cm) of height (or length depending on the character). Excess wire can be cut off in the end.

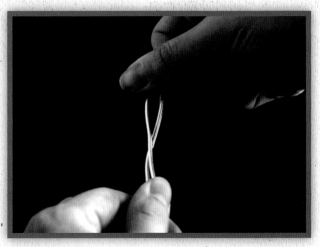

2 Pinch the wire at the fold with one hand. A few inches (several centimeters) down, pinch the wire with the other hand. Begin twisting the wire together, going in an opposite direction with each hand. Pull in both directions as you are doing this to keep the twists tight.

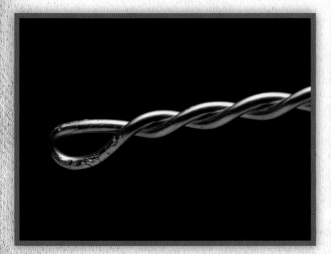

3 Keep the twists as tight and even as possible; this will ensure that your armature remains structurally sound. Twist until you have a length that is appropriate for the neck and head of your character. See step 4 for a diagram of how to properly measure your proportions by using your armature layout.

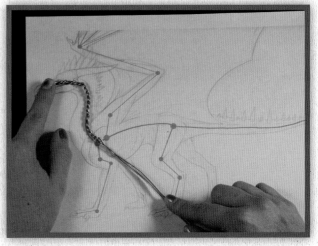

4 As you are creating each portion of the body, lay your armature wire against your layout to check for accuracy. If you take your time and do this right, your armature will be the exact same size and proportions as your layout drawing.

FIELD NOTE

If you are having a hard time twisting the wire with your bare hands, use pliers in one or both hands.

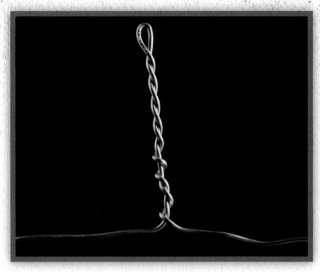

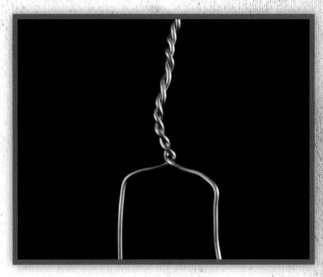

5 Separate the wires off to each side of the neck. Each side will be used to create an arm. Make certain to use one side of the wire per arm or you will quickly run out of wire.

6 Before measuring out the arms, make sure to compensate for the rib cage area. This will ensure that the arms don't look like they are sprouting from the neck and will allow room to add foil for the torso later on.

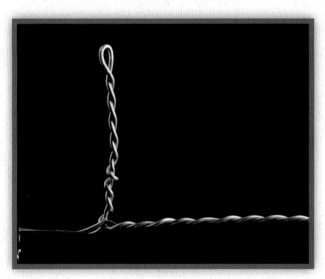

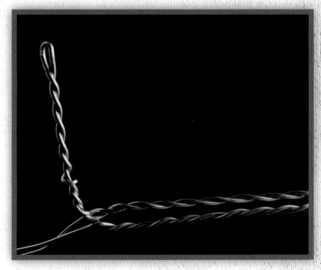

7 Measure out each arm including the hand. At the end of the measurement, fold the wire back in on itself and twist all the way up to the neck. Again, make certain you are using one side of the wire per arm.

8 Once you have measured and twisted both arms, your armature should appear similar to this image. Make sure there are no gaps and that everything is as neat and tight as possible.

FIELD NOTE

You may have noticed the loops forming at the end of the extremities. These will be useful in attaching your armature to a base.

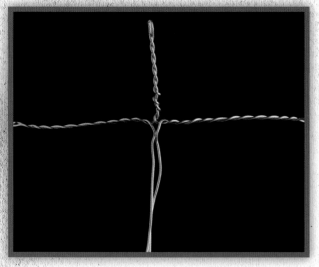

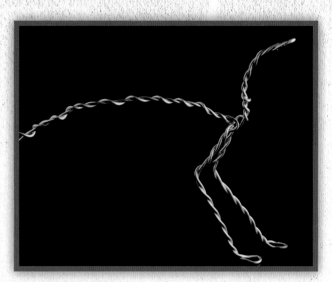

9 Top View, Before Torso Twisting: To create the torso, twist the remaining wire back, twisting until about mid hip.

10 Side View, After Torso Has Been Created: You may choose to start bending your armature into place at this point if you'd like, but it's not necessary.

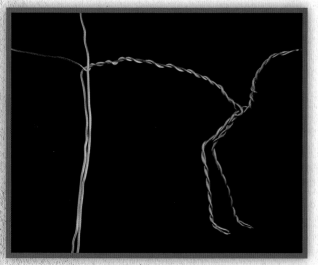

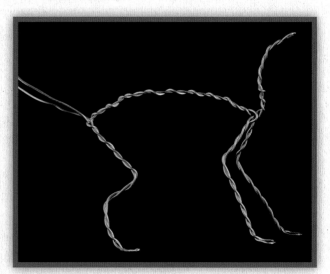

11 Separate the wires off to each side of the hip, just as you did with the arms. Each side will be used to create a leg. Just as with the shoulders, make sure you compensate out to the sides for the hip area so you can later build up with foil.

12 Measure out each leg, then fold and twist back up to the torso. This is the exact same thing that was done with the arms, so it should be a breeze!

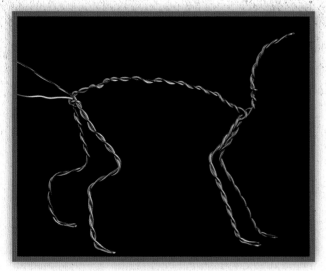

13 If the character has a tail, the excess wire can be twisted back behind the hip area. Otherwise, you can trim the excess.

14 At this point, you may want to bend your armature into position to double-check your proportions against your layout for accuracy. You don't need to bend it into the final pose just yet, but at least get all of the joints bent into place.

TIPS FOR SPECIAL CHARACTERISTICS

EXTRA LIMBS: Start with extra length on the wire (2 feet [61cm] or so per set of limbs). After creating the front set of limbs, twist down a little for the torso. Stop where the shoulder of the second set of limbs lies and create them just as you did the first set. Repeat for each set of limbs until you hit the hip and finish the armature as normal.

MULTIPLE TAILS: For two tails, keep the excess wire split off into two rather than twisting it together to form one tail. For more than two tails, wrap an additional length of wire along the torso. Allow the excess wire to run off the back of the hip for the tails.

VERY LONG HORNS OR SPINES: Most of the time, horns and spines can simply be made of clay and added on during the main sculpting process. However, if you have a horn, spine or similar protrusion that might not be able to hold up its own weight, you may wish to include it in the armature. Wrap a piece of wire around the main armature where you want the horn/spine to protrude. Once it is secure, bend the wire into position and snip at the appropriate length.

ADDING WINGS TO AN ARMATURE

You may decide to create an avian or dragon character that will mostly likely need a pair of wings.

1 Determine the length of the wing span and cut four lengths (or however many fingers you want the wing to have) of thin gauge wire matching this length, plus about an inch or two (3–5cm) to hold the wings into place on the main armature. If you are creating bird wings, only one length of medium gauge wire is needed.

2 Determine the center point by folding the lengths in half. (For bird wings, move on to step 4.) From the center, twist the wires together to one side. Stop once you have reached the hand area of the wing. The extra lengths will become the fingers of the wing.

3 Repeat step 2 for the second wing.

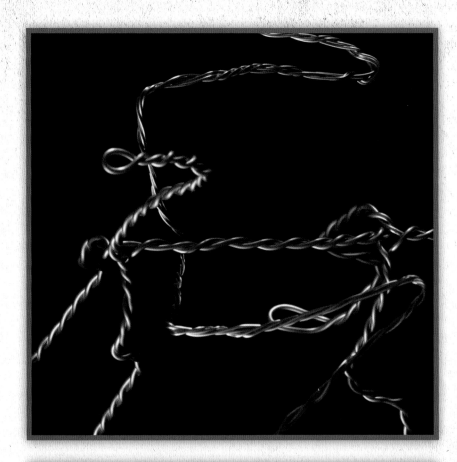

4 Hook the wings under the main part of the armature at the point where the wings join the body. Wrap the wings around the main armature to hold them in place temporarily.

5 Wrap thin wire around the connection point until the wings no longer shift around. Epoxy or hot glue can be added for extra strength.

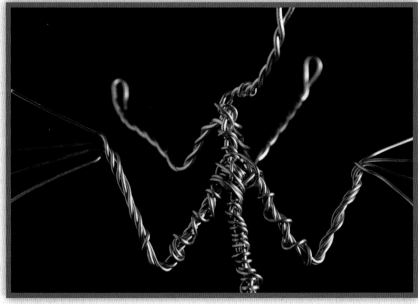

FIELD NOTE

You don't need to worry about feathers or membranes just yet. We will be implementing wire mesh in just a while; for now, just work on the main wing structure.

CREATING A STRONGER ARMATURE

If your figure is in a dynamic or more complex pose, an armature beyond the basics may be needed. This armature technique is especially useful in poses where most of the figure's weight is balanced on one or two limbs.

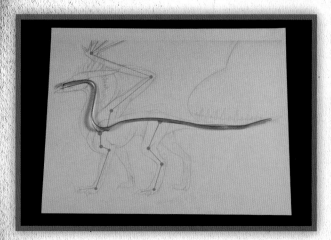

1 Using heavy gauge wire, measure and cut a length for the head, neck, torso and tail. We will not be twisting this time, you will be happy to hear!

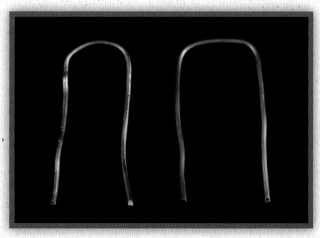

2 Measure and cut two more lengths of wire, this time for both legs and both arms. One piece should be long enough to build both front legs, and the other, both back legs. Leave a little extra length on each to attach the limbs to the body. Fold the wires in half evenly.

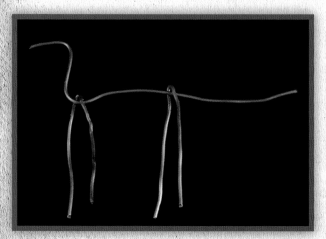

3 Hook the limbs into place over the top of the spine. You may want to mark the overlap point on the spine using a permanent marker.

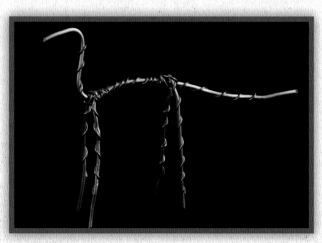

4 Use medium gauge wire to wrap the limbs in place as tightly as possible. Also be sure to wrap some wire around the length of the limbs, torso and tail. This will give some texture to the wire so the clay has something to grab on to.

FIELD NOTE

Be sure to crimp down all sharp wire ends with your pliers so you don't scratch your hands.

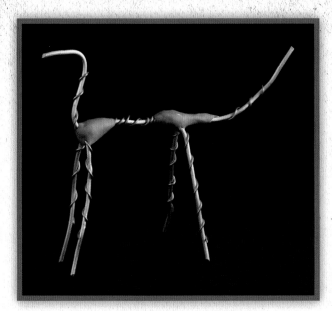

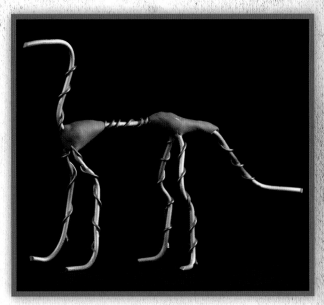

5 Mix together some Apoxie Sculpt. Use this to reinforce the shoulders and hips. Be sure not to use too much or you will restrict how much the wire can be bent later. Look at the photo above for reference.

6 Once the Apoxie has fully cured, the armature is now ready to be bent into position!

Visit **www.impact-books.com/fantasy-creatures-in-clay** for more amazing bonus features!

31

DYNAMIC POSING

One of the most important things to remember about sculpting is that your piece can be viewed from all angles. Unlike a drawing or painting, you need to focus on making many angles look good, not just a single one. True, a sculpture almost always has a "hero side," but it should look good no matter from what angle you view it. Creating an interesting and dynamic pose is key to a successful sculpture.

1 Start with your completed armature in a neutral pose. Unless your project specifically calls for this, I do not recommend leaving your armature in such a position. It is very dull to look at, and there is no movement to the pose whatsoever. Notice how linear the form looks from both the side and the front.

2 Begin posing your armature. I've decided I want to put this character in a leaping type pose. It's definitely looking better than what I started with, but it could still use work. Notice from the side view it looks very interesting, but when viewed from the front, it's nowhere near as dynamic.

3 With some different bends in the torso, the front view is starting to look much more interesting. Notice the zig-zag positioning of the different parts of the body; this is a sign of a strong pose. You never want straight lines in a dynamic pose.

4 Just a little more tweaking, and I have my finished pose! Your final pose should look awesome on the hero side, the view you want your sculpture to be seen from most of the time. But it should also look interesting and dynamic from other angles.

FIELD NOTE

If it still looks boring, then exaggerate the line of action to get a more interesting pose. You can always dial it back later if need be.

BASE ATTACHMENT
AND FURTHER REINFORCEMENT

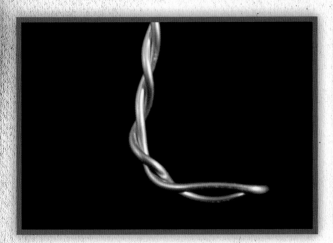

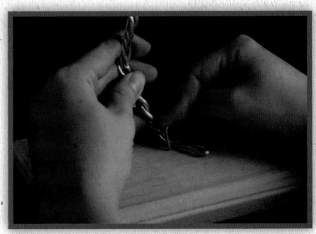

1 Bend the loops for the feet so they are at a 90 degree angle to the leg. This is only for the feet that will actually be touching the ground. Position the armature atop your wood base in the desired orientation.

2 Be certain that the feet are in the exact place they need to be. Place the first U-nail over the wire foot near the ankle. Take care in placing nails near the edge of the base; the wood can split easily there.

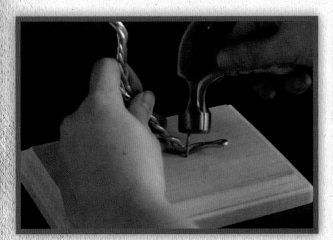

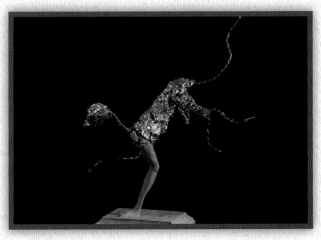

3 Tap the nail with a hammer until it is completely embedded into the wood base. Use two or three U-nails to attach each foot to the base. When complete, the armature should feel sturdy and not shift around when touched.

4 If your armature is balancing a lot of weight on one or two legs, it's a good idea to further reinforce those legs with Apoxie Sculpt. Use it sparingly as you don't want to bulk up the legs too much before you put clay over the top. Run the Apoxie from the foot up to at least the elbow or knee. This will ensure better stability and will help keep the final baked clay from cracking under pressure.

FIELD NOTE

Sometimes U-nails will go in crooked. To prevent this uneven entry into the wood, try alternating the direction you are approaching the nail with the hammer. If you need to remove a U-nail, try using your pliers.

CRIMPING JOINTS

Crimping the joints (knees, elbows, etc.) with pliers can help add realism to your structure. You want the joints to come together at an angle, rather than a smooth curve. This will help prevent what I call "gumby arms," or limbs that look like they have no bone structure.

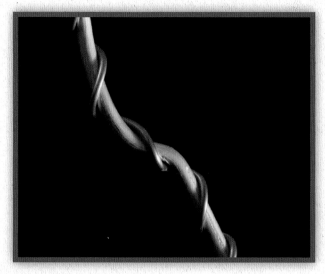

1 This photo shows the knee and ankle joints before crimping.

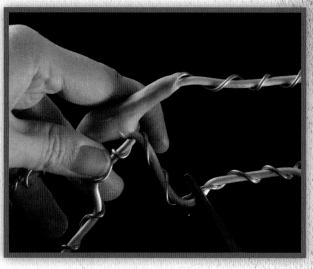

2 Use the pliers in your selected location to crimp the joint areas up.

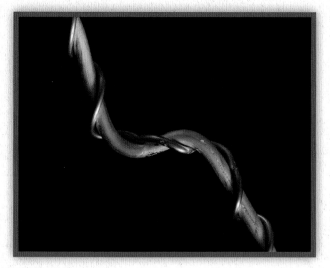

3 This photo depicts the joints after being crimped.

FIELD NOTE

If you want to make your figure removeable from the base, this is easily accomplished through the use of a drill. Choose the appropriate drill bit that matches up with the thickness of your armature. Line up your armature on the base and mark where each foot stands. Drill a hole for each foot that will be touching the base. The extra inch (3cm) of wire at the end of each leg can now be fed through the base. This will secure the sculpture in place but you will be able to remove the figure as you are working. You can also easily put the figure back into place on the base.

ADDING VOLUME
WITH ALUMINUM FOIL

To keep your sculpture lightweight and to conserve clay, bulking out thicker areas of your sculpture with aluminum foil is very helpful. This will also aid in keeping the clay firm during sculpting so that the clay doesn't give in to the pressure of your hands. Foil only needs to be used in thicker areas of the sculpture, normally the torso and head. You may choose to use some foil on the upper arms and thighs as well, depending on the character and size of your sculpture. Keep the foil off thin areas like wrists and ankles. If you apply too much foil, your sculpture will become oversized and you will lose your proportions. Leave enough room to compensate for about $\frac{1}{8}$–$\frac{1}{4}$" (3–6mm) of clay around the whole sculpture.

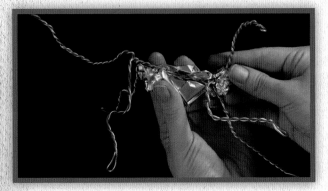

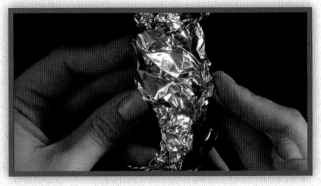

1 Tear off the foil into square foot pieces; these can be halved and quartered as needed. Wrap the foil around the armature and compress the foil tightly.

You don't need to compress the foil so tightly that it becomes like a rock. However, the foil shouldn't easily shift around on the armature. You don't want it to give in easily to touch or it will be difficult to apply clay.

2 Continue building up the foil, taking care to build out to the sides. This will keep your sculpture from looking flat.

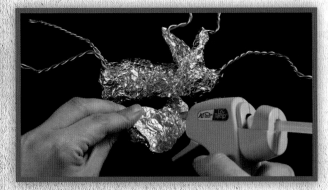

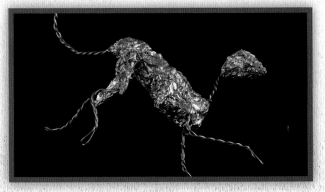

3 If you are having a hard time keeping a particular piece of foil in place, you can use a dab of Super Glue or hot glue to help keep it in place.

4 This armature is now done with foil. I can always tell I didn't overdo it with the foil if the character looks emaciated! With practice, you will be able to tell more quickly how much foil is enough.

COMPLEX ENVIRONMENTS

When creating bulky or complex environments, a modified armature will be needed in order to compensate for the objects with which the character is interacting. In this example, the dragon is scaling a rocky cliff face. Notice that none of his feet touch the wood base below the cliff. But the armature should always be directly attached to the base for stability's sake. To figure out how to make this work for your project, you will want to create a plan for how you are going to integrate the character into the environment. This will normally involve adding extensions onto the legs. In my example here, I measured the legs as normal, but when I hit the rock, I continued them down until they hit the base. I then covered the rock area with foil, hiding the extensions. This will give the illusion of the character standing atop the objects on the base.

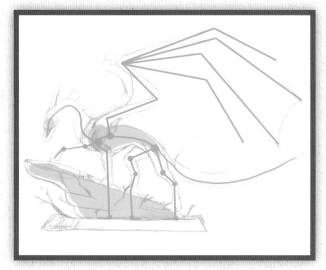

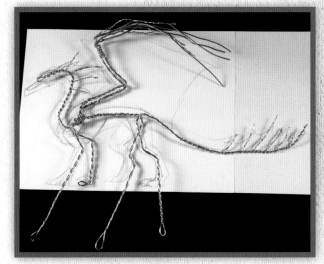

1 Decide on the layout you want your clay creature to have with the environment surrounding it. Then draw the arrangement of how you're going to compose your armature in its environment.

2 Use the armature layout in conjunction with the environment plan to create the armature. The main proportional measurements will still be based on the layout. However, adjustments will need to be made according to the environment plan. For example, on the dragon's left arm, I noted on the plan that the length from the elbow to the foot was the same as the length from the foot to the base. I could then measure and lengthen the wire for the arm accordingly. Make sure to add an inch or so (2–4cm) extra to anchor the armature to the base.

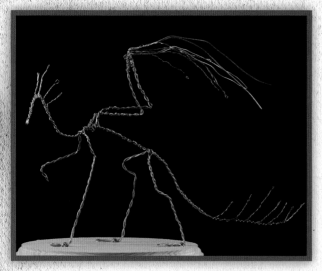 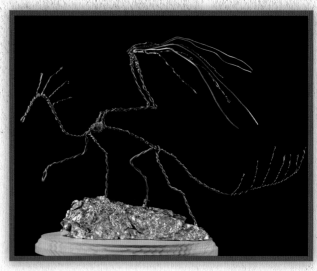

3 Pose the armature into position and anchor it to the base as described previously. Use hot glue or epoxy putty for added strength and stability. The legs will likely look superlong at this point, which is correct!

4 Build up foil around the leg extensions. Stop about ⅛–¼" (3–6mm) inch from where you want the feet to sit; remember, you will be building up the base with clay later. Hot glue the foil into place on the base.

FIELD NOTE

Sculpting the base in full detail first and baking it before working on the character will help give even more stability while you work. It can also help give a better impression that the character is standing on top of the environment.

USING WIRE MESH

Wire mesh is a wonderful tool that can help to build out thin or flat aspects of a character such as wings, capes or other flowing cloth. I will show here how it can be used to make wing membranes, but it can be used in a large variety of applications.

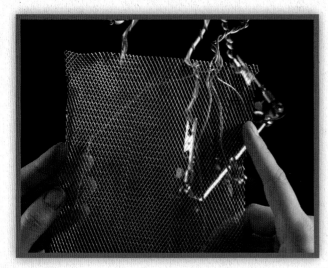

1 Cut off a portion of wire mesh and lay it across your posed wing.

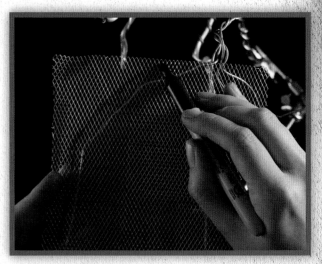

2 Using a Sharpie pen, trace out the first membrane segment. Be sure to include some excess so you can wrap the mesh around the main armature.

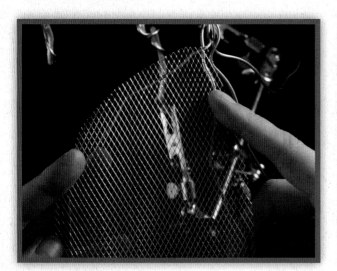

3 Carefully cut out the segment with scissors. Be very careful as the edges of wire mesh are very sharp. You may wish to use some masking tape along the edge to ensure safety.

4 Place the membrane segment into position on the wing. Wrap the edges along the armature, securing them into place.

Visit **www.impact-books.com/fantasy-creatures-in-clay** for more amazing bonus features!

39

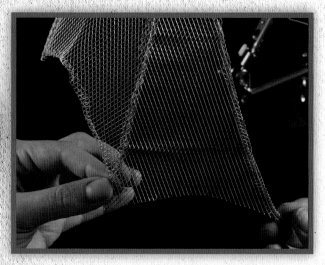

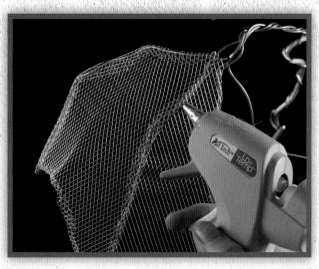

5 Create the next segment of the membrane, repeating steps 1–3. On the side not touching the previously made segment, wrap the mesh around the wing armature.

6 Use hot glue along the overlapping membrane edges. Be careful handling the armature as the hot glue will heat up the metal.

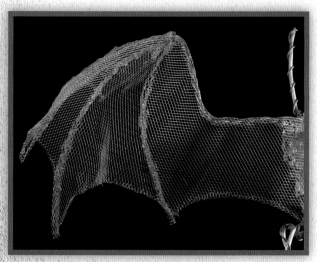

7 Repeat this process until the wing is complete. You may wish to fold in the edges of the wings to shape them and to get rid of the sharp wires.

FIELD NOTE

To help speed up drying time, hold the glued area in place with a metal tool and gently blow on the hot glue until it has cooled.

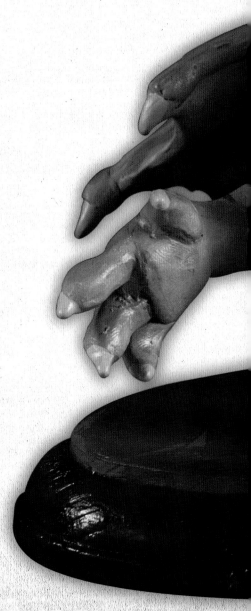

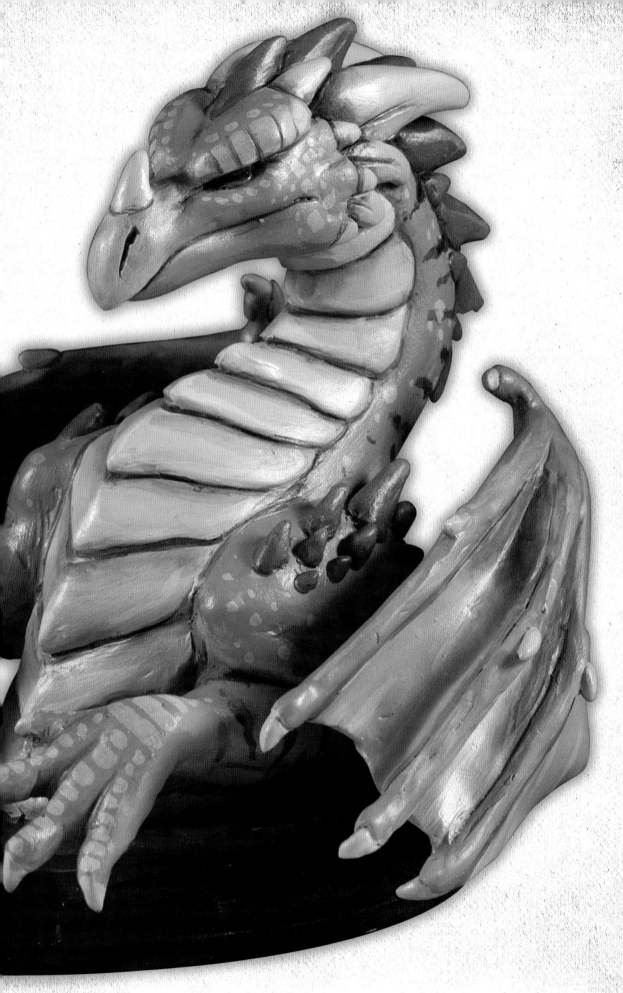

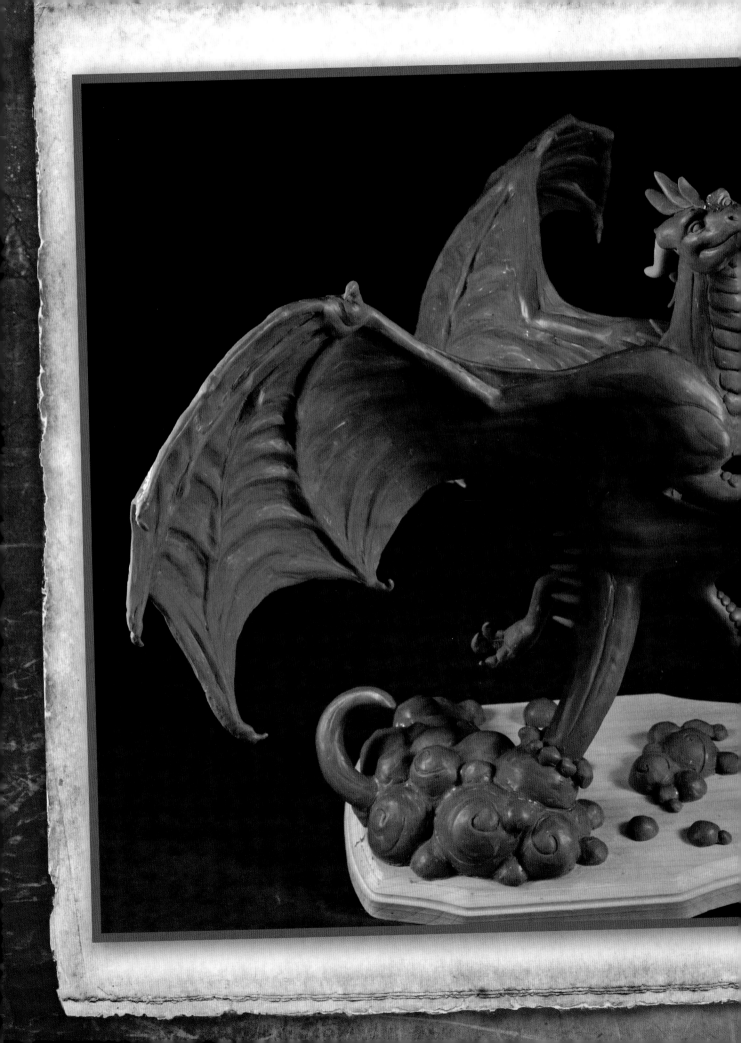

SCULPTING BASIC FORMS

Well, we are a quarter of the way through the book, and we're finally ready to start with clay! Before worrying about any sort of details, it is important to rough in a basic form with clay.

This chapter shows the use of Monster Clay in the demonstrations. Like everything else in this book, the techniques shown can also be applied to Sculpey. Prior to working, the clay will need to be warmed up and softened a bit by kneading small pieces in your hands prior to adhering them to the armature. If you are working with Sculpey, try creating a $^{50}/_{50}$ blend of Super Sculpey and Sculpey Firm by rolling out sheets of both with a pasta machine. You can stack the layers and continue to run them through the pasta machine until thoroughly blended.

We will begin by quickly blocking out the main form of the structure to show basic proportion, form and action. This form will initially be very rough. From there, we will discuss different smoothing and refining methods that will start bringing those lumps of clay to life. Finally, we will add in anatomical details as well as secondary forms. We are laying down the foundation for the details and textures we will create in the next chapter.

BLOCKING BASIC FORMS

The first thing to focus on when starting with clay is to get all of the basic forms laid in. This is known as the blocking phase. This is similar to a gesture sketch for a painting or finished drawing. During this phase, you want to work quickly, worrying only about the overall proportions and pose; you are laying the foundation for details that come later on.

1 Use flat pieces of clay that resemble the shape of the body part that you are sculpting. I always start at the torso on my sculptures since everything else on the body is built off this central area. Here, I have formed a shape that will be used for the side of the rib cage.

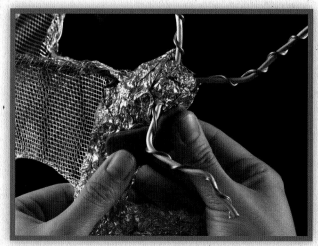

2 After the proper shape has been roughly formed, press it onto the armature and smooth it into place with your fingers. Don't worry about getting the clay overly smooth at this point. The primary goal is to get the clay to form the desired shapes while keeping it firmly in place.

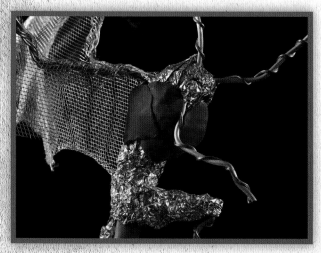

3 Continue forming flat pieces of clay and pressing them onto the armature. Smooth each piece of clay into the ones neighboring it, smoothing only just enough to get the impression of the shape.

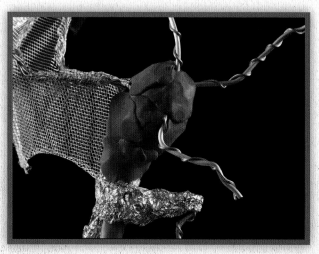

4 Here is the right side of the blocked-out torso. While it still looks very rough, the impression of a rib cage is already starting to show. Be sure to give the same treatment to the left side of the rib cage as well.

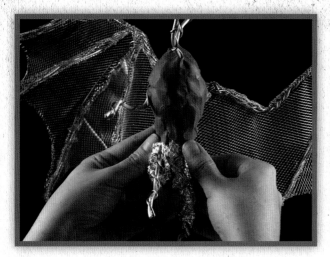

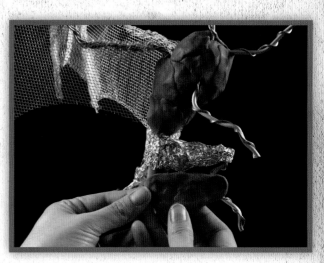

5 Again, every angle is important, including the front. Make sure the forms look accurate from different views; this will save you a lot of time and energy when detailing.

6 Once the torso has been built up, it's time to add the limbs. I start with this tapered shape to form the thigh. Each segment of an arm or leg tapers from thick to thin. The hip tapers to the knee; the knee tapers to the ankle; the ankle widens to form the foot. Keeping this idea in mind will simplify the creation of limbs.

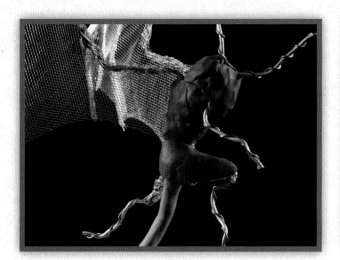

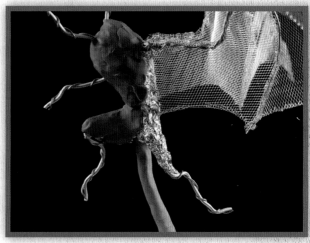

7 Just as you did with the torso, press the piece of clay onto the armature to form the thigh. Be sure to smooth it in with the torso as well.

8 Form the inner thigh using the same method as the outer thigh. Add some additional clay to connect the inner thigh to the underside of the torso.

FIELD NOTE

A great thing about using pliable clay over aluminum wire is that it can always be bent and shaped to some degree. If something is looking strange about the pose, don't be afraid to carefully tweak the positioning of the armature.

Visit **www.impact-books.com/fantasy-creatures-in-clay** for more amazing bonus features!

45

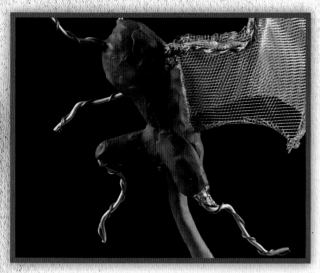

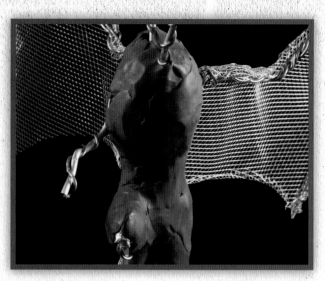

9 Repeat the same process for the other side. Be sure to give the hips some form and start hinting at a bone structure that is lying beneath the surface.

10 As you continue building up the forms, you may notice that previously built forms are lacking in mass. To ensure proper proportions, it is very important to continue adding to forms even after building new ones.

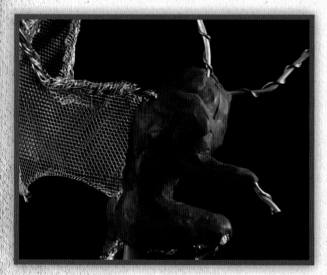

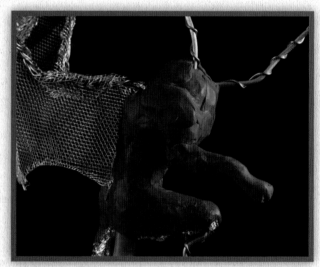

11 Add the arms, shoulders and forearms. Laying down the clay pieces in a well-thought-out order will give the impression of overlapping muscles. The forearm is added on as well, keeping in mind the thick to thin tapering seen previously in the legs.

12 The hands are formed using simple shapes. There is no need to worry about fingers at this point. Just get the overall shape and position of the hand. Thinking of the hand as a mitten can be helpful when trying to create the proper shape.

FIELD NOTE

When applying clay to wire, make certain that it is not shifting around or this will cause problems later on. Pinch the clay against the wire until it is securely in place. You may find it helpful to lightly coat the wire in clay before applying the large forms.

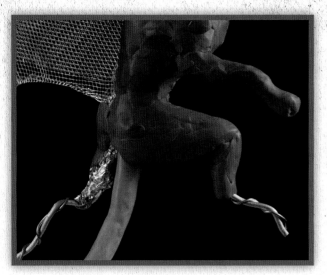

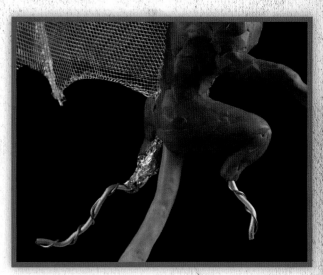

13 If a limb is bent inwards to the point it causes compression of the muscles, it is helpful to bend the joint at a 90 degree angle before applying clay. This was done here with the knee. The calf muscle can then be sculpted in full without having to compensate for said compression.

14 After the calf muscle is fully sculpted, the leg can be bent back into place. You will notice that the clay will compress and give the desired look. When bending, grip the bare wire of the foot with pliers so as not to damage the clay on the calf.

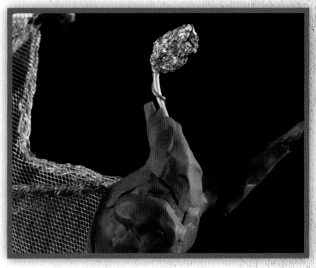

15 The foot can now be applied. As with the hands, don't worry about sculpting digits just yet.

16 It is now time to work on the neck and head. It is important to taper the neck properly so it appears to be growing from the torso rather than just stuck on to it. Notice how the neck is broad at the base where it meets the chest and starts to taper as it moves towards the head. The tapering will vary from creature to creature, but it will always be present to some degree.

FIELD NOTE

If you are having difficulty with the anatomy on the limbs, here is a useful trick. Using a tool, draw in a very basic stick figure skeleton over the limb you are trying to correct. It gives a point of reference to build the muscles around. Using this method in conjunction with solid anatomy reference will greatly simplify positioning the muscles of the limbs.

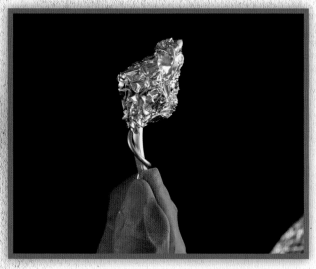

17 The neck tapers from the back and front as well. Continue building up the neck towards the head. Be certain that the form follows any curve.

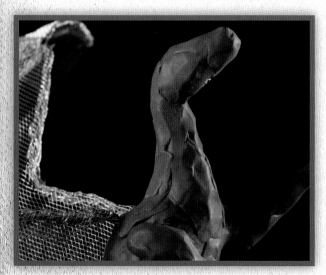
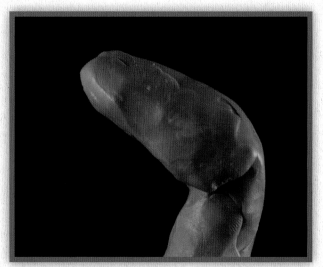

18 From the neck, move on to the head, blocking in only the most basic shape. No facial features should be represented at this point unless they are extremely oversized and/or prominent. Even then, they should look very rough and basic.

19 Using separate pieces of clay on either side of the head, build up the jawline. Blend this into the face and back of the neck, but leave a seam along the jawbone as seen here. This will give the proper appearance of the head growing from the neck.

FIELD NOTE

To get the form accurate, I often break the head down into two separate shapes. I used a sphere or wedge shape for the cranium/jaw portion, and I then attach another wedge shape for the muzzle or snout.

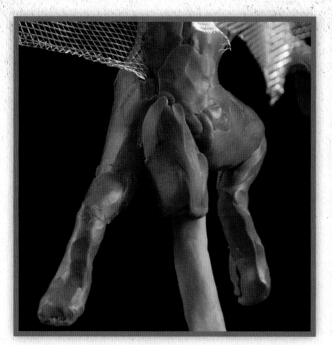

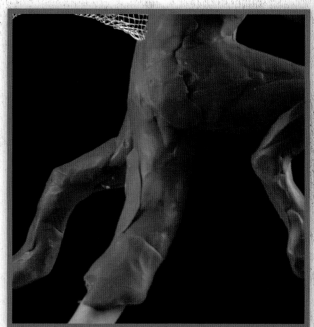

20 The tail is an extension of the spine. When blocking out the tail, keep this fact in mind to ensure that it doesn't look simply stuck on. In general, tails are broad at the base where they meet the body, and slowly taper off towards the tip. Notice in the photo that the shape of the tail actually overlaps the hip area. When viewed from the side, it appears that the tail is growing out of the back of the creature.

FIELD NOTE

If your creature has a fluffy tail like a fox or a wolf, the tail will appear narrow at the base and get wider before tapering to the tip. Some tails barely taper at all, like that of a house cat. Other tails are short and therefore taper much quicker, as can be seen in animals like turtles. The variations are endless!

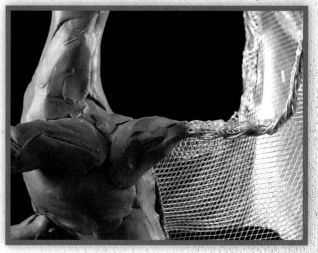

21 Also be sure to properly attach the tail to the underside so it looks like it is growing out from the spine at this angle as well.

22 Think of wings as an extra set of arms. They have the same basic structure with a shoulder, elbow and wrist. Attach the wing to the body by creating the shoulder muscles. It will take a little creativity and lots of wing muscle reference.

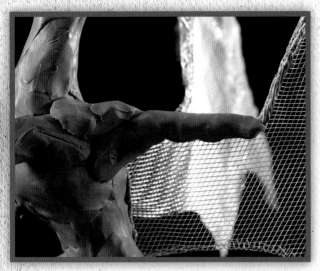

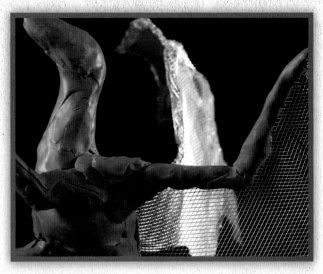

23 Continue building up the wing arm by blocking in the bicep and tricep muscles. Build up the shoulder to form the deltoid over the top of the arm. Build up the forearm all the way up to the wrist. For now, we will be leaving off the wing fingers and wing membranes for easier access to the piece as a whole.

24 I find it cumbersome trying to work on finer details of a sculpture when the wings are already fully sculpted as they add a good bit of weight to the piece. I also like to be able to easily bend them out of the way without worrying about damaging them.

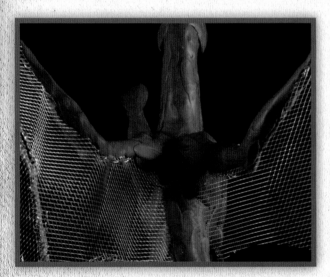

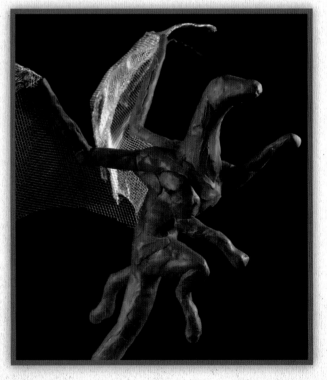

25 This is what the finished blockout looks like. Quickly blocking out a sculpture in this rough manner is key in getting correct proportions and dynamic action. I also believe it gives inspiration and drive as you get a pretty good idea of what the final piece will look like with very little work.

REFINING A BLOCKED-OUT SCULPTURE

These are the points that will be addressed during the refinement phase :

- ❧ Surface Quality - Beginning to smooth out major cracks, seams and bumps in the clay.
- ❧ Defining Anatomy - Showing muscle definition as well as protruding bony landmarks.
- ❧ Main Details - Adding secondary forms such as the face, fingers/toes and large scales.

❧ DEMONSTRATION

SMOOTHING METHODS

Before defining an area of the body, you first want to smooth out the major imperfections in the clay. All of those cracks and bumps that developed during the blockout now need to be blended away. There are two methods I use when smoothing clay.

I normally tackle one area at a time; first smoothing and then defining anatomy. I then go back and add the large details throughout the sculpture. The images in the following demonstrations show the piece before and after the refinement stage.

FIELD NOTE

Feel free to go back and forth between using your hands and using the tools. Keep working the area until it seems relatively smooth and streamlined. The goal isn't a polished surface but instead an accurate form to lay a foundation for the anatomy.

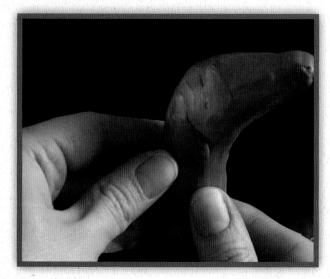

1 The first method is simply using your hands. Hold the sculpture as gently as possible in both hands, supporting the area you want to smooth. Use your thumbs to gently push and pull the clay into shape.

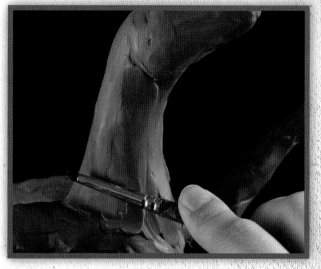

2 Once I have smoothed out an area with my hands, I refine even further using a rubber tool. I often use the metal barrel of the tool to smooth clay into place. The rubber tip is perfect for smoothing out hard-to-reach areas like between fingers or along seams such as the jawline.

CREATING SEAMS

There are areas of the body where two or more muscles meet and/
or overlap, creating a visible seam. This first example demonstrates
the simplest way of creating such a seam in the neck muscles of
this character.

1 Start by marking in the seam using a rubber
tool. Lightly mark it in at first to get your
placement correct.

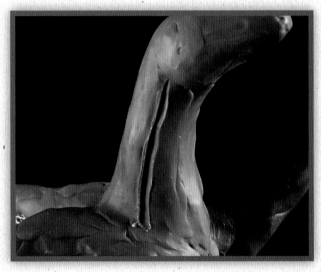

2 Pass the rubber tool over the seam several times
until you get a deeper line. Don't gouge the clay
but make it a little deeper than it should be as
you will soon be scaling it back.

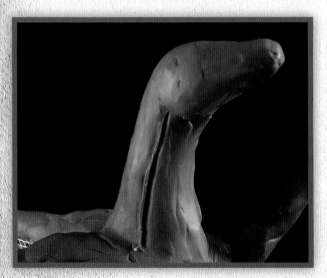

3 Using either your hands or the rubber tool,
gently smooth the seam, pull the clay from the
center of the seam out so you don't rub the line
away. Notice the right side of the seam has been
smoothed while the opposite side is still rough.

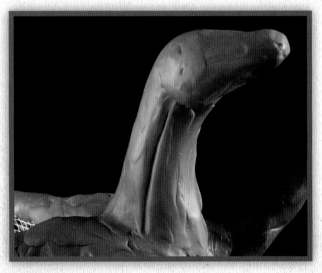

4 Notice how much more shallow the seam has
become in the smoothing process. Be sure not
to smooth so much that the seam disappears or
becomes hard to see. This process becomes
much easier with practice.

ADDITIVE FORM

After smoothing an area, it may be necessary to add more clay to the form to get the correct shape and flow. When you add clay to a sculpture, you are using an additive method. This will be done continuously throughout the refining stage to both make corrections and build up muscles.

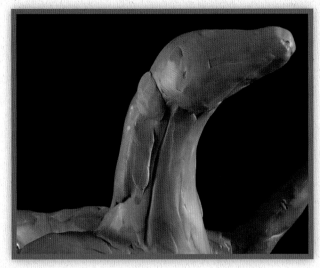

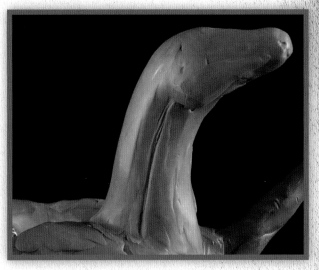

1 After smoothing the neck and placing the seam in the center, I decided that the back of the neck didn't look like it was flowing into the head properly. I pressed a few bits of clay onto the back of the neck in the same loose manner as when the sculpture was being blocked out. Adding this extra mass helped the anatomy look much more accurate.

2 The clay is then smoothed into the rest of the sculpture, taking care not to blend away any of the seams.

FIELD NOTE

I often add more clay than needed and then remove the excess afterwards using the subtractive method. Since there is so much control by doing this, I find the combination of additive and subtractive to be the best way of achieving accurate surfaces.

SUBTRACTIVE FORM

Often during the blockout of a sculpture, some areas may become too big or bulky. They will need to be pared down using the subtractive method of sculpting. Like the additive method, this will be done throughout the entire refining phase. The subtractive method is great for getting the precise curvature of the forms and muscles.

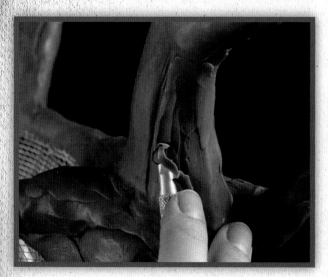

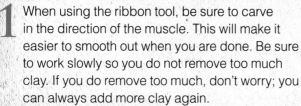

1 When using the ribbon tool, be sure to carve in the direction of the muscle. This will make it easier to smooth out when you are done. Be sure to work slowly so you do not remove too much clay. If you do remove too much, don't worry; you can always add more clay again.

FIELD NOTE

Using subtractive methods can be messy with clay shavings going everywhere. Clay can get stuck in carpet and destroy nice furniture. Be sure to work in a space where you (or the rest of your household) don't mind a mess.

Also, if you are using Sculpey and your clay is smooshing around, try putting the sculpture in the freezer for fifteen minutes before using the carving tools. The photos here show two different loop tools, both adept at subtractive sculpting methods.

DEFINING ANATOMY

Now I really hate to sound like a broken record, but I cannot stress enough how important it is to have plenty of reference in front of you when sculpting. This is especially true when recreating anatomy. Even after

sculpting for over a decade, I still pull out my anatomy books to reference while I am working; learning anatomy is a lifelong discipline.

∾ DEMONSTRATION

ARMS

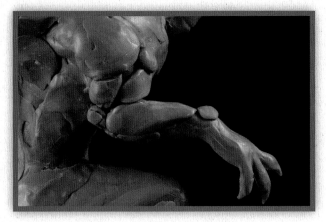

1 Start to define the muscles and bones in the arm. Create flat pieces of clay that mimic the shapes of the muscles and bones that you want to build up, then lay them into place on the sculpture in the appropriate spots.

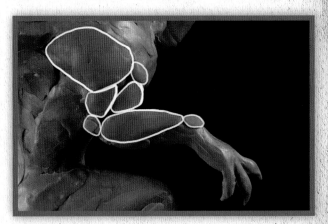

2 Where a bone is seen on the surface of the skin as a groove or prominence, this is referred to as a bony landmark. Major bony landmarks include elbows, knees, shoulders and hips. You can see in blue that I have defined the shoulder, elbow and wrist joints.

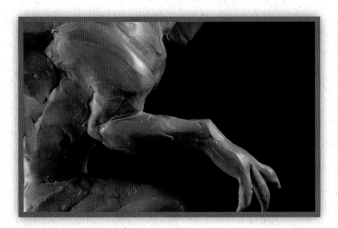

3 Smooth the shapes of the muscles and bones into the rest of the form.

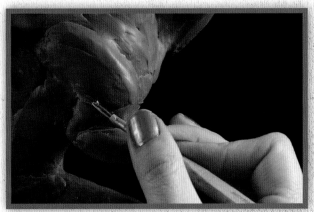

4 Continue to add more definition. Using a fine line wire loop tool or even a rubber tool will do the job just fine. Simply run the tool along the crease between the muscles to make it deeper. You can then go back with a rubber tool to soften the line if needed.

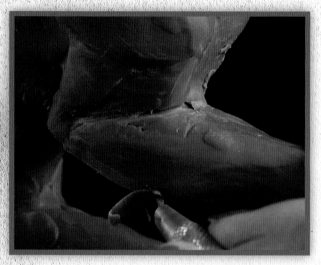

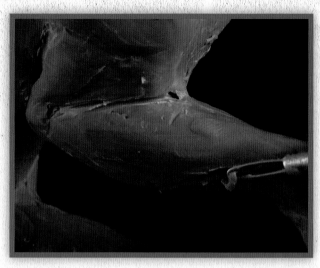

5 Definition can also be added directly to the form, not just the seams and creases around it. Using a ribbon tool, remove some clay from the form, moving in the same direction that the muscle flows. This will help define the surfaces or planes of the muscle. Also be sure to taper the muscle as needed. Here, I modified the muscles of the forearm so they appear to be wrapping around the arm properly rather than in a linear fashion as they were previously. I also further defined the thick-to-thin tapering between the elbow to the wrist joints.

6 After smoothing out the upper arm, I added a definition line to highlight the muscle that I just created. Always be sure to smooth in these lines so they look more natural; just be careful not to remove so much that the muscles start to look overly soft or pillowy.

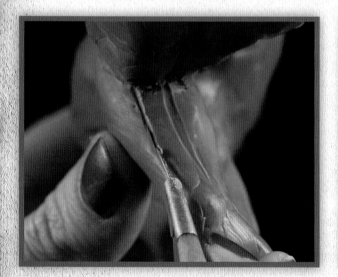

7 Sometimes bones will protrude through the skin slightly. Drawing the edges of the bone with a tool and then smoothing the lines will help add that definition.

8 I also added a thin strip of clay to the top of the bone in the forearm and smoothed it in. Be sure not to overdo this or you risk making your character look skeletal or dead. But if you want that, go for it!

RIB CAGE

Another good example of protruding bone is the rib cage. This is a particular area you don't want to have too much definition or your character may start to look emaciated. In most cases, you want to keep the lines between the ribs subtle.

1 Draw in the lines of the ribs.

2 Build the ribs up with strips of clay in the center, between the lines.

3 Smooth everything in.

FIELD NOTE

Don't be afraid to make your sculpture look a little messy during this stage. You don't want to be destructive, but marking reference lines is a very helpful technique. These lines can easily be erased or can become part of the finished sculpture!

LEGS

1 First, the bony landmarks are laid in: the hip, knee and ankle.

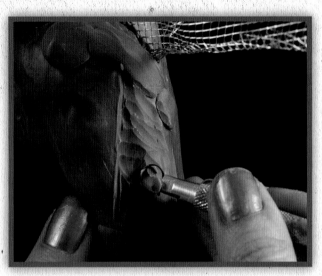

2 You may have noticed some guidelines I drew on the leg. These lines show me what direction the bone and muscles should be flowing. The lines will also help me create some seams. Starting from the seam I drew, I use the subtractive method to scrape away at the leg and shape the muscles. The plane changes in leg muscles are more subtle than those of arm muscles. I find that using the additive method on legs builds them up too quickly and they become bulky.

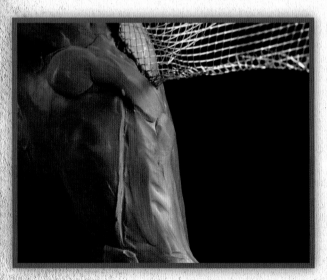

3 The texture that results from the scraping is smoothed in and the process repeated for the other side of the leg.

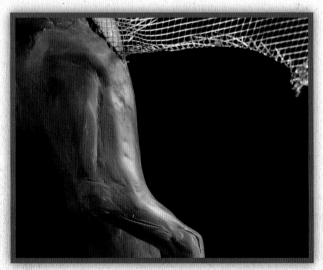

4 The bony landmarks are also smoothed in, leaving definition. Although the techniques being used may vary, the process is always the same: build up, scrape away and smooth.

BUILDING THE HEAD

The head is a very important part of a sculpture. It is generally the first thing someone will look at, and it is highly detailed. While we won't be getting to all those details just yet, it's time to start giving the head more definition and form.

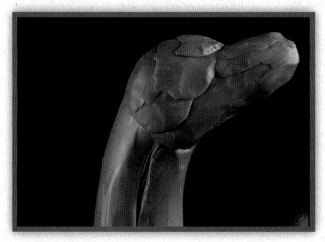

1 Start by adding and/or subtracting clay to get the overall shape of the head looking more accurate. Here, I added extra clay to the top of the head to lay the foundation for the forehead and brow. I also added more length to the snout.

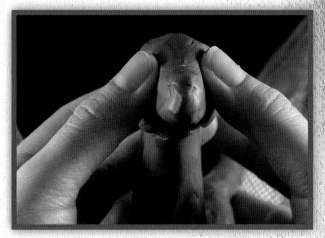

2 Once the head shape is corrected and smoothed, it's time to press in some eye cavities. Much of the structure of the face is based around the eyes, so this is a good starting point. Looking at the head from the front, I press two sockets into the head using both thumbs, keeping them both as even and level as possible.

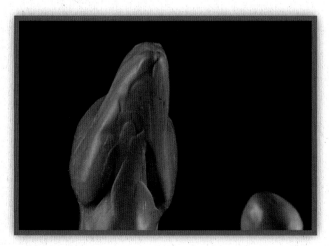

3 Using two strips of clay, build up the jawline. This will both add definition to the face and make the neck appear to be properly connected to the head. Smooth in the strips of clay, leaving some definition along the outside edge of the jawbone. You may wish to use a rubber tool to define the jawline even further.

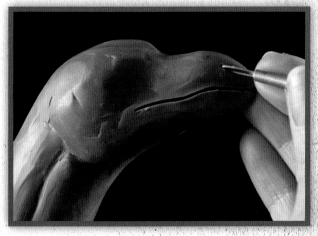

4 Mark in the mouth and nostril details using a metal tool.

Visit **www.impact-books.com/fantasy-creatures-in-clay** for more amazing bonus features!

59

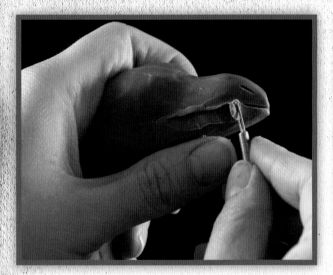

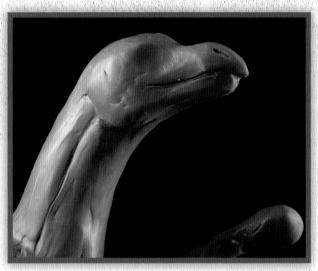

5 Using the mouth line as a guide, remove some clay from the lower jaw. This will give the impression of the upper jaw overlapping the lower.

6 Smooth the edges of the mouth and nostril with a rubber tool to take away the hard look. You now have the main shape of the head ready to be detailed.

FIELD NOTE

Keeping symmetry is especially important with the head and face. I like to draw a vertical center line to help keep the features even on each side of the face. Drawing a horizontal line around the cranium where the eyes sit can also help keep features lined up properly.

FORMING CLAWS

Remember to build your character from everyday references. Even though a dragon is a fantastical creature, it would make sense for it to have features similar to those of other predators found in nature.

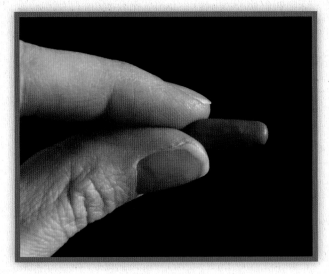

1 Roll out the fingers or toes individually. Each will start as a basic cylinder. All of the fingers and toes will have slightly different lengths. I like to use my own hands as reference when sculpting fingers.

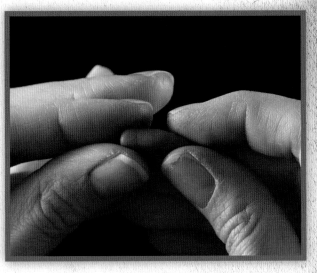

2 Pinch the tip of the finger to form a point for the claw.

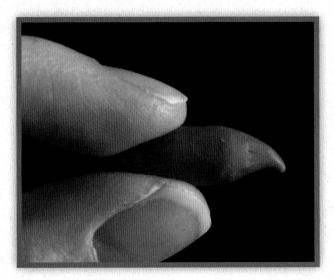

3 Gently add a curve to the claw by running your finger along the top edge.

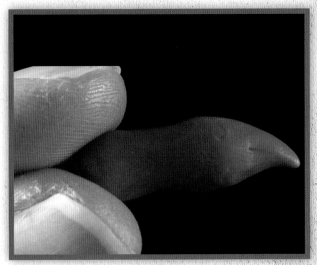

4 Pinch in the center of the finger to form a basic joint. This will help you pose the fingers more accurately. The joint will be further defined later.

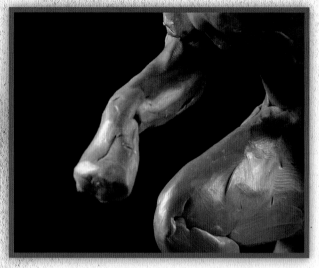

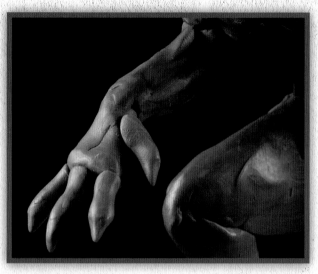

5 Remove any excess clay from the hand until only the palm form remains. You will be attaching the fingers directly to this form.

6 Place the fingers onto the hand. Take a look at your own hand and notice the slight arch in which your fingers are arranged on your hand, with the middle finger being at the highest point on the arch. Arrange the fingers on the hand so they simulate this arch.

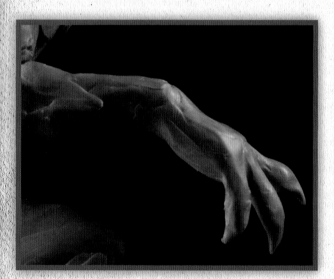

7 Smooth the fingers into the hand, and pose them as you'd like. Add some mass if needed to the knuckles along the backside of the hand.

FIELD NOTE

Curling the fingers and toes slightly will give a natural look to them. Relax your hand and notice how your fingers naturally curl inwards. Fingers are only straight and level when forced into that position.

PAWS

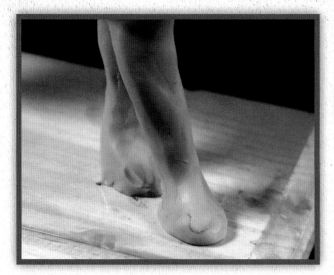

1 The blocked form of the paw should appear similar to this image. Pay attention to the specific animal you are recreating. While the basic method of sculpting paws remains the same between species, there are some structural changes.

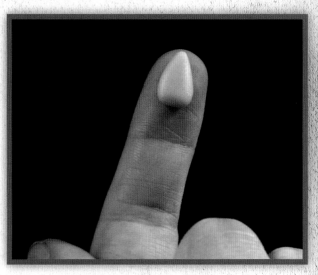

2 Create four flat teardrop-shaped pieces for each foot.

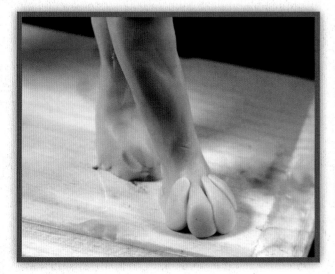

3 Arrange the toes on the foot. The two center toes should protrude farther forward than the outside two.

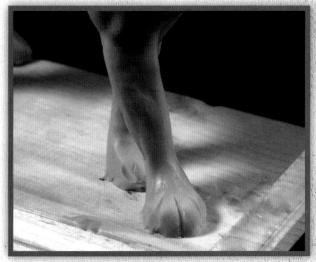

4 Blend the toes into the foot, making sure to leave definition to the lines separating each toe.

OVERLAPPING SCALES

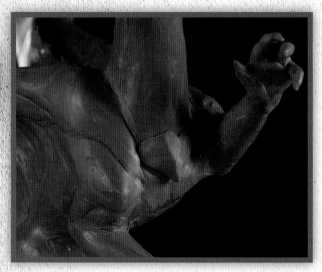

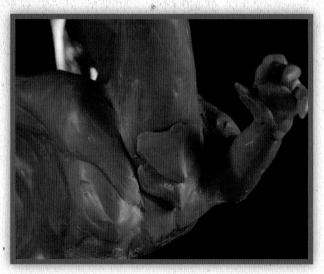

1 Large scales such as ones along the underbelly are considered part of the main structure. I add these after all the anatomy has been sculpted so they don't get misshapen during sculpting. I start with the scale at the bottom of the stacking order. In this case, the scale falls at the base of the neck. I like to use a rough heart shape for large scales. Form the scale, place it on the sculpture and smooth the base of the scale into the neck. Smoothing the base gives space to stack scales on top of each other.

2 The next scale is formed and placed atop the previously made scale. The edges of the lower scale are cleaned up so the overlap looks accurate. Scales should change in size depending on where they are on the body. In this case, the scales will slowly taper as they move up the neck towards the head.

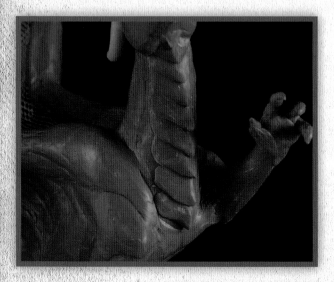

3 Here is the final result of the overlapping scales. Notice how the centers of the scales line up with the center of the neck. This gives the appearance that the scales are moving with the neck. Once all the scales are in place, I like to go back and do a final cleanup of all the outside edges of the scales so the overlap and the gradual size change look their best. I also shave down any excess clay on each scale using a metal ribbon tool.

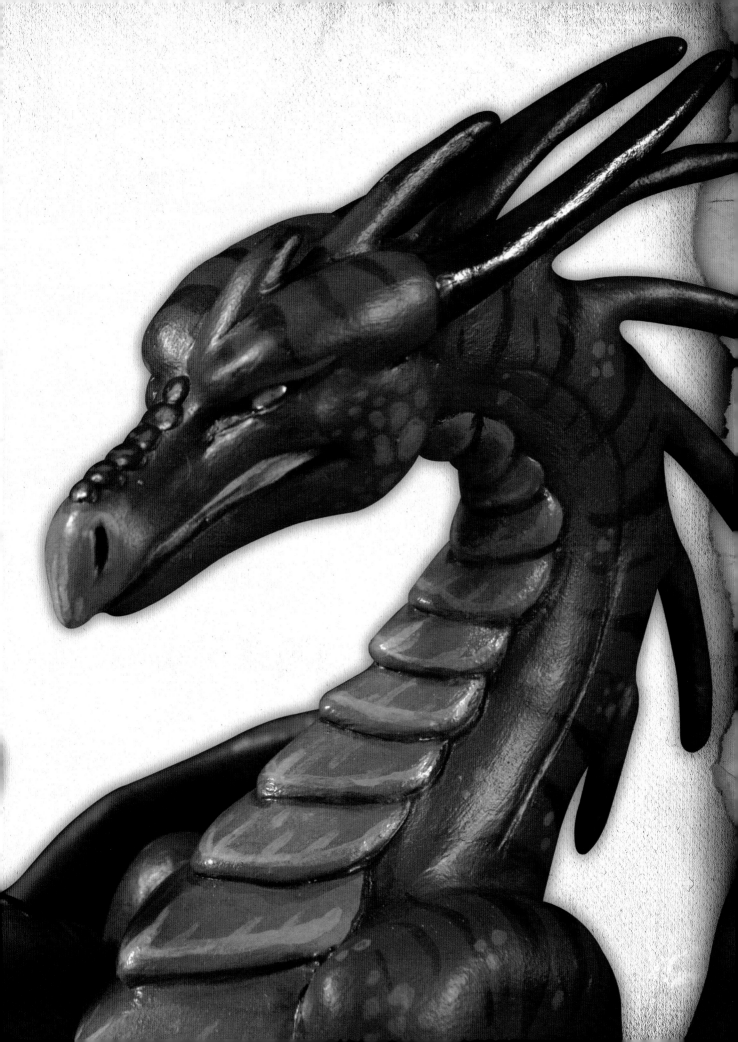

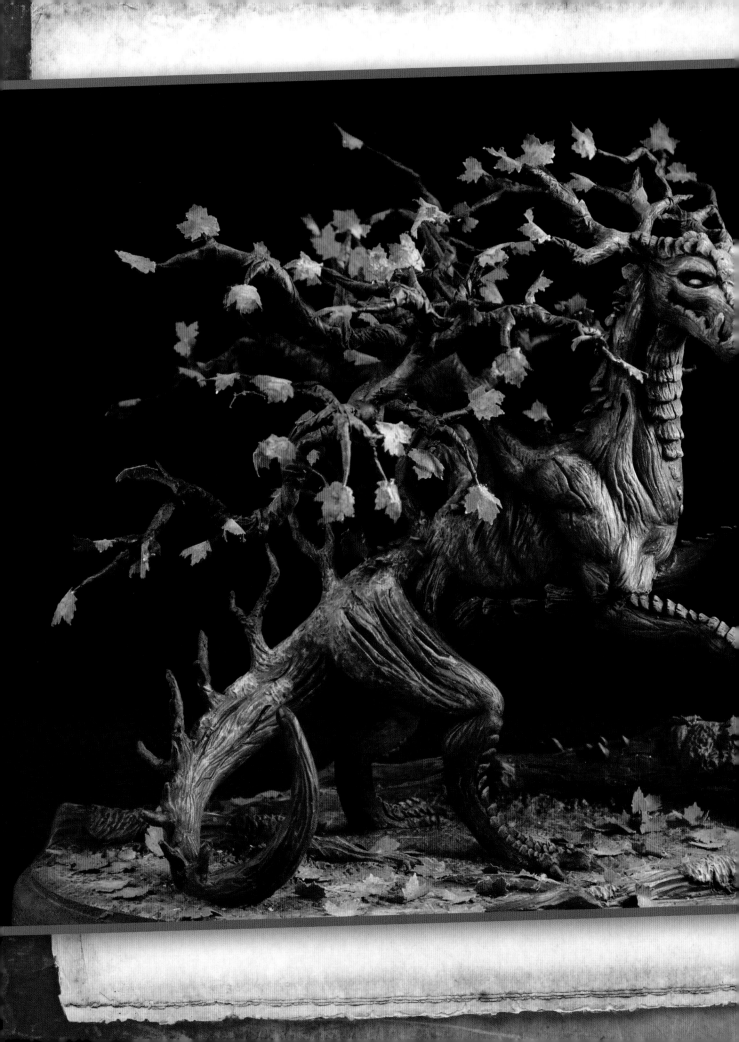

ADDING TEXTURE AND DETAIL

At this point, you should have all of your main forms sculpted. Now it's time for the best part: detailing! This is where your sculpture is really going to take on a life of its own and all of your hard work will truly start to shine.

Monster Clay holds an incredible amount of detail and is wonderful for creating lush textures. You will be amazed how quickly you will be able to create fairly lifelike textures without losing detail while working. Super Sculpey can also hold fine detail, especially if you have mixed in Sculpey Firm. However, as mentioned before, Sculpey becomes soft and unworkable at times. While it may not have been too big a problem when working with the larger forms, it can become a problem when you are trying to sculpt fine details and crisp edges. Remember that you always have the option of placing the sculpture in the freezer for fifteen to twenty minutes. This will help preserve fine details.

One of the great qualities about Sculpey is that it can be baked multiple times without ruining the integrity of the piece. Rigid details such as horns, spikes, teeth and claws can be baked in the oven to harden and then inserted into the main piece. These pieces can now keep their form as you are working on the rest of the sculpture. The entire piece can later be baked without any adverse effects. Prebaked Sculpey pieces can also be used in conjunction with Monster Clay.

In this chapter, I will be going over a variety of texture creation techniques. We will also discuss various methods of detail creation such as facial features, fingers and toes, horns and spines, and feathered wings. I will once again be using both Monster Clay and Sculpey to demonstrate these ideas. Keep in mind that detailing is highly experimental. Once you've learned how I do things, experiment and figure out some of your own methods!

Detailing the Face

In this section I will cover techniques on how to detail faces. Since there are so many different kinds of animal and creature faces, I will be showing several varieties that many other creatures can be derived from. Facial structures vary greatly from predator to prey, from land to sea, and from climate to climate.

∼ DEMONSTRATION

Lion

These techniques can be applied toward canines, rodents and other land mammals.

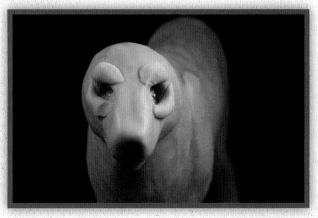

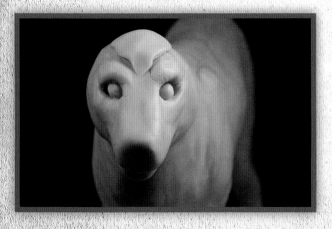

1 First, we must deepen the eye sockets. Scoop out two eye sockets using a metal ribbon tool. Make sure they are deep and on the same level as each other.

2 Build up the eye ridges and cheekbones using thin strips of clay. Make sure they follow the contour of the eye sockets. To create the eyes, roll out two spheres that are slightly smaller than the eye sockets.

3 Smooth the eye ridge and cheekbone structures into the face, making sure to keep some visible definition. Place the eyes into the sockets, making sure they are set back into the head and not protruding from the face.

Build up the forehead using a piece of clay and smooth it into the head.

FIELD NOTE

You should bake your character's eyes because most eyes are almost perfectly round. Using soft clay for eyeballs results in distortion once they are being sculpted around.

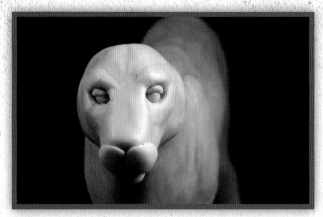

4 Create the top eyelids using small strips of clay. Place them over the top part of the eyeball, making sure the seam touching the eyeball stays clean and follows the contour of the eyeball properly. Do the same for the lower lids. Blend the lids slightly into the head.

Begin building the shape of the muzzle using round, flat pieces of clay on either side. Smooth them into the face while leaving the seams present where the mouth will be placed.

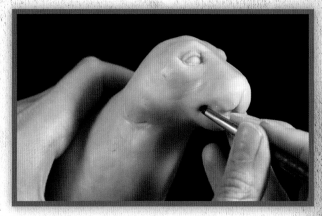

5 Use a rubber tool to further define the mouth and round out the lips. Mammals like lions have a dip in the corner of their mouths, which is shown here being defined.

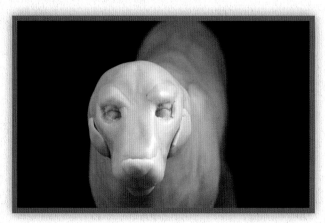

6 Build up the cheeks and jaw using small pieces of clay; blend them into the face. Create a triangular piece of clay for the nose and put it into place on the face.

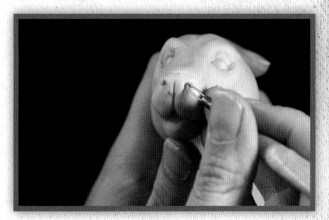

7 Tool in the nostrils using a small loop tool or similar detailing tool. Press up and in to create the proper shape. Add a line down the center of the nose that lines up with the split in the muzzle. Note that the nose should be thicker where it meets the bridge and thins out as it moves down towards the mouth.

Visit **www.impact-books.com/fantasy-creatures-in-clay** for more amazing bonus features!

71

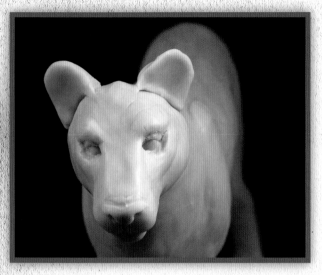

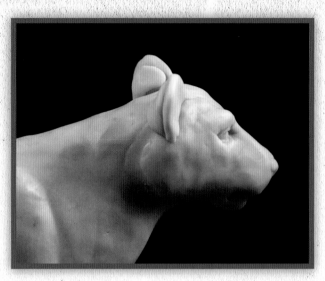

8 Create the ears using two triangular pieces of clay and place them on either side of the head. Make sure they are even and facing slightly out.

9 Build up the backs of the ears using flattened balls of clay. Smooth these into the ears and then blend both ears into the head.

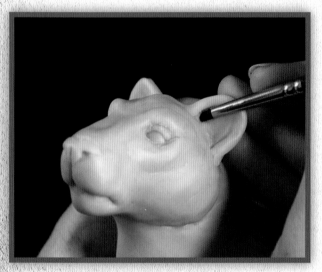

FIELD NOTE

Want to add a touch of realism? Try using glass taxidermy eyes. They will add a whole new layer of depth to your faces. They are available prepainted as well as blank so you can paint them as you need them.

10 Press a rubber tool into the ear to create the inside of the ear as well as the rim.

PHOENIX

Techniques can be applied to most birdlike facial structures to create creatures like griffins.

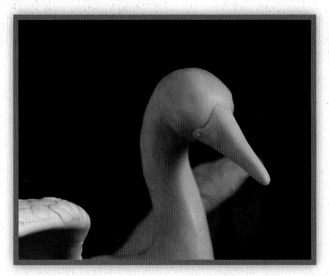

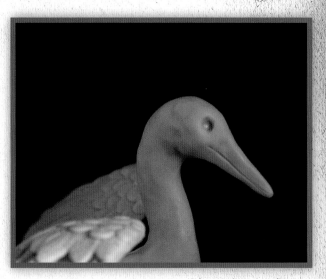

1 I begin with a refined phoenix sculpt. Birds (or avians) have a rather simple but unique facial structure. First create a pyramid shape for the beak and attach it to the face. Make sure to use reference for the specific shape you are looking for as it will vary greatly between species.

2 Blend the beak into the face and draw in the mouth line using a needle tool. This line may be curved or straight depending on the bird species. I based this phoenix on a crane, so the mouth seam is straight. Create two eye sockets.

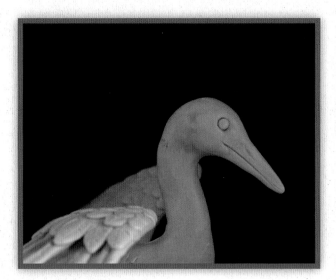

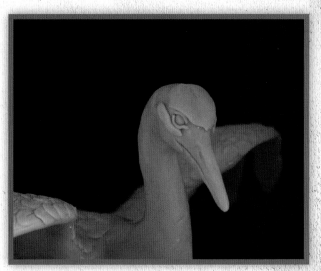

3 Place a pair of prebaked eyeballs into the sockets. In avians, the eyes often face out to the sides rather than forward. Tool in the nostril detail as well as the seam that separates the beak from the rest of the face.

4 Build up the forehead and eye ridges as well as the eyelids using small, appropriately shaped strips of clay.

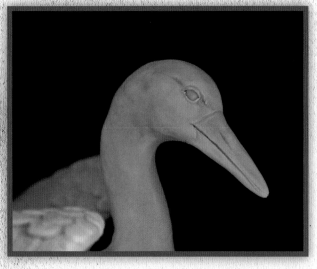

5 Smooth in the forms and create further definition between the beak and facial features.

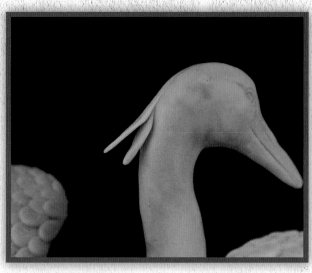

6 If desired, add crest feathers one at a time starting from the base of the head.

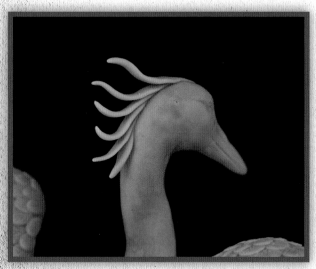

7 Continue layering the feathers, adding a little bit of a curve to each one as you go along. Be sure to increase or decrease the size of the feathers as needed. Making the feathers uniform in size and height looks unnatural.

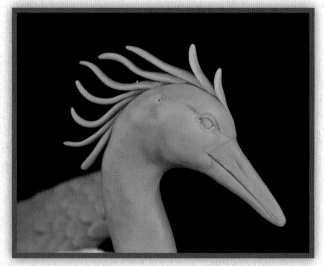

8 Notice that the feathers get smaller at either end of the crest, while they are longest near the center. Not all crests follow this arc, but it was what I chose for this piece.

HORSE

Techniques can be applied to many hoofed mammals.

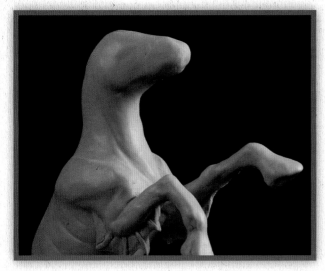

1 The facial structure of horses and other hoofed animals is very distinct. To demonstrate, I will use the refined form of this sea horse character.

2 I create two shallow eye sockets using the end of a rubber tool. The eyes of hoofed animals tend to be bulgy, so the eye sockets don't need to be too deep here.

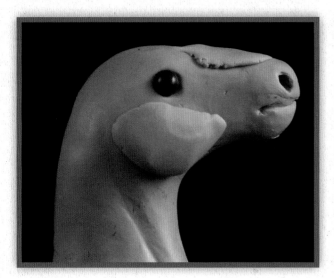

3 For the eyes, I have used two black wooden beads. These beads will be baked with the sculpture and later painted over. Once the eyes are placed, I mark in the nostrils and mouth using a metal tool. They are rough for now but will be smoothed as I move forward. I also added mass to the jaw and the bridge of the nose to further define these areas of the face.

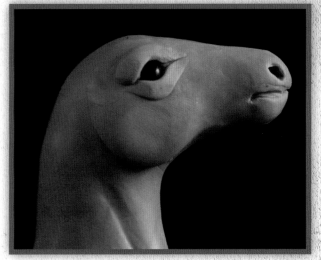

4 The masses from the last step have been smoothed into the face. I also refined the shape of the head a bit, especially around the nose and mouth. The eyelids are built up next, using separate strips of clay for the upper and lower lids. They are then smoothed in with the rest of the face in a similar manner shown in the previous head demonstrations.

Visit **www.impact-books.com/fantasy-creatures-in-clay** for more amazing bonus features!

75

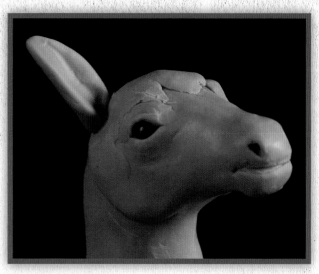

5 After the ear shape is formed, I gently press the metal barrel of a rubber tool into the center of the shape to round it. Finally, I pinch the ear at the base to prepare it for attachment.

6 I added some more mass to the top of the head before attaching both ears. Be sure that both ears are level with each other and are facing the proper direction.

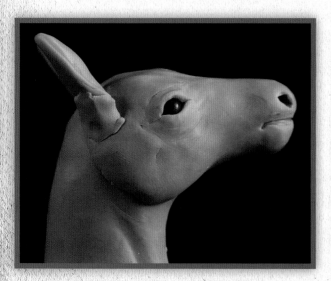

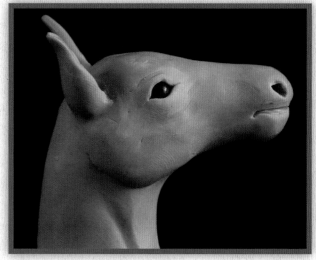

7 As shown in the photo, I added mass to the base of the ear. This will help give the final shape to the ear as well as make it appear to be growing out of the head.

8 Finally, everything is smoothed out and details are refined. The ears were a little too big, so I removed some of the clay before giving them their final shape. Notice the slight curve present in the tip of the ear; this is much more naturalistic than having the ear stick straight up.

DRAGON

The dragon face here has a combination of features from the other animals shown. He is a great example of combined anatomy.

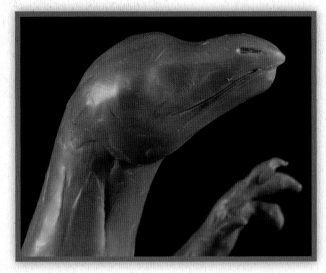

1 I will use the dragon sculpt that I have been working with in the past few chapters. You will notice that much of the process is very similar to that of the lion head. However, I want to show how similar techniques can be applied to different forms.

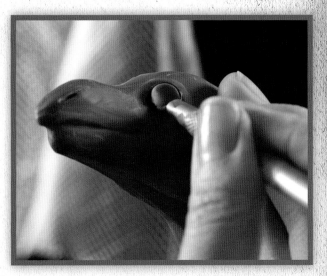

2 As with the other head sculpts, we begin by carving out the eye sockets. For dragons, deeper set eyes can be a nice look.

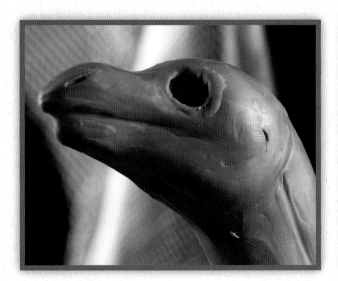

3 Make sure to clear out any excess clay.

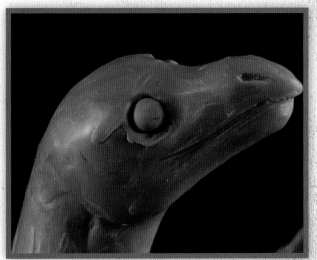

4 Place the eyes into the sockets, making sure they look even from all angles. I used small spheres of Monster Clay for the dragon's eyes as it generally holds its shape pretty well.

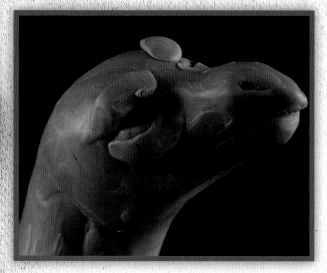

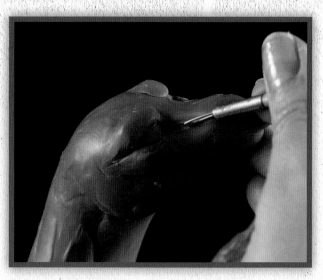

5 Build up the eye ridges and cheekbones using small strips of clay. Blend these in with the rest of the face. Making the features more pronounced can add a dramatic look to your creature.

6 Use a fine metal tool to define the lines around the eyes and corners of the eyes.

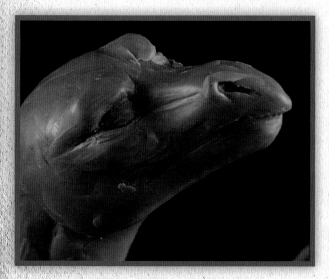

7 Use thin strips of clay around the nostrils to further define them. Blend them in around the outside edge to give the appearance of a fleshy ridge.

8 Roll out a long, tapered cone shape of clay appropriate for the shape and size of the horn. Shape the horn with your hands. Here, I've created a backwards sweep to the horn with just a few pinches. Create the second horn and then bake them for ten minutes at 275°F (135°C).

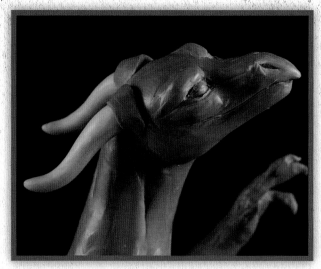

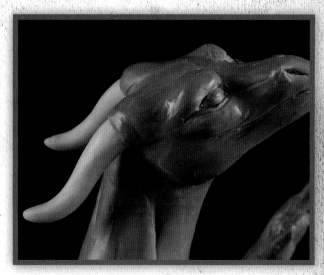

9 Once cooled, insert the horns into your unbaked piece. Using thin strips of clay, cover the base of each horn.

10 Smooth the strip into the head, but leave the other side to form a seam against the horn. This will make the horn appear to be growing from the skull rather than just stuck to the back of the head.

FIELD NOTE

Vary and exaggerate the features of your dragons. Just remember to keep them believable by following your knowledge of anatomy and nature.

Visit **www.impact-books.com/fantasy-creatures-in-clay** for more amazing bonus features!

79

SPIRALLED HORN

Dragons are fantastical creatures and are therefore not limited to standard ideas of what things should look like. Try playing around with the designs of your animal—like making your dragon have spiralled horns!

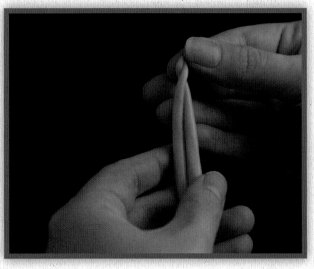

1 Start with two equal-sized tapered cones. They should be fairly thin since you will be combining them to make the thickness of the horn.

2 Align the two cones and twist them together as shown. You may have to pull on the ends a bit to get the horn to taper fully.

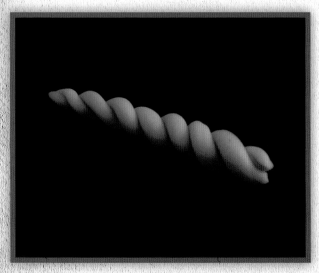

FIELD NOTE

You can apply this technique to most any type of bony or rigid protrusions such as spines or spikes, pretty much anything that needs to keep a rigid shape that isn't going to move. For example, even though scales are rigid, they also move with the muscles, so you wouldn't want to bake those before applying them.

3 Now you can bake your finished horns for ten minutes at 275°F (135°C), cool and then apply to your sculpture as shown in the previous steps.

Hands and Feet

We already have a good start to the hands and feet, but there is still another level of detail to be added. Adding in tendon and knuckle detail, sculpting the pads, as well as adding claws will finish off the hands and feet.

~ DEMONSTRATION

ADDING CLAWS

1 Start by making long, thin triangular pieces for each claw. They should vary slightly in size depending on which finger or toe they will be.

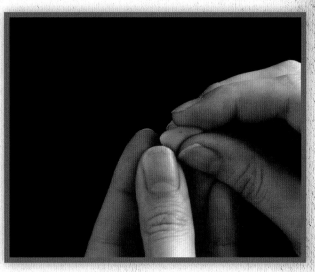

2 Hold the claw in one hand. With your other hand, use the tips of your thumb and forefinger to bend and shape the claw into a curve.

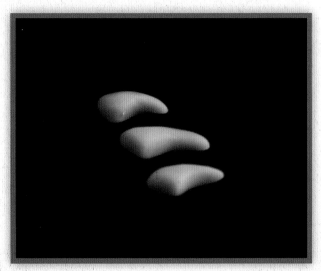

3 Bake the claws in the oven for about ten minutes at 275°F (135°C). Once cooled, the claws can be inserted into the fingers and toes.

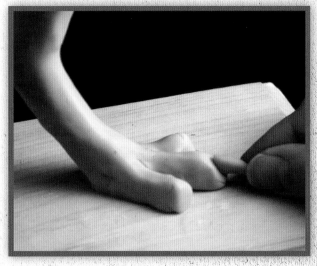

4 Notice that when you push the claw in, a cuticle forms itself.

HAND DETAILING

Try to make your hands as lifelike as possible.

1 We had a pretty good start to the hands at the end of the blocking and refining stage. They still need some more detail in the joints of the fingers and pads on the palms. We will add in some tendon detail as well.

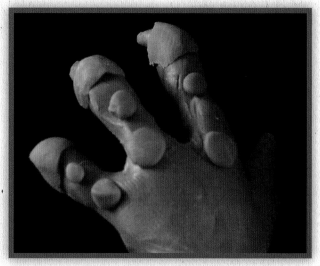

2 Use flat discs of clay to create the knuckles. They should get smaller as they move towards the tip of the fingers. I also add a strip of clay around the base of each claw to further define the cuticle. Add some definition to the wrist joint here as well.

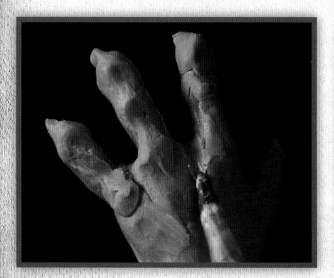

3 Smooth the joints into the fingers very carefully using a rubber tool. Press the tool between the fingers and draw a line towards the wrist to create tendons.

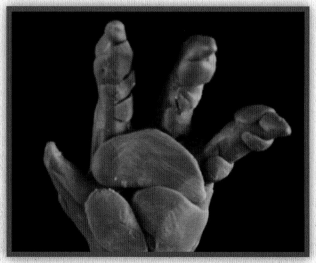

4 Add bulk to the pads of the fingers as well as the palms. I always use my own hand for reference here. The pads of the fingers should correspond with the joints. Smooth in the pads, leaving definition at the creases.

FOOT DETAILING

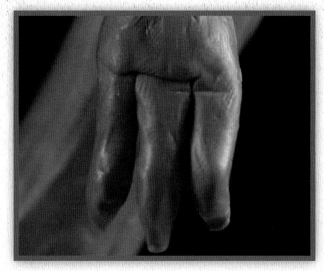

1 The feet will be detailed in a similar fashion to the hands. We begin with a refined form of the foot of the same dragon character.

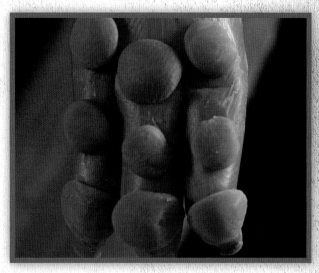

2 Use flat discs of clay to create the joints. As with the hands, the knuckles get smaller as they move towards the tips of the toes. Strips of clay are wrapped around the base of each claw to further define the cuticle. Smooth the joints carefully into the toes.

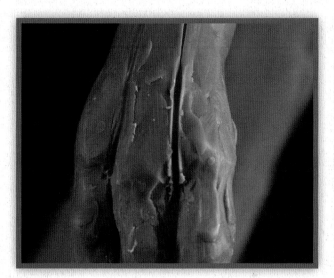

3 Using a metal detail tool, add some tendon detail. Start with the tool between the toes and run it up the length of the foot. The line should taper off before it reaches the ankle joint.

4 Add bulk to the pads of the toes and the ball of the foot. The pads of the toes should correspond with the joints. Smooth them in with the rest of the foot.

FIELD NOTE

I use a little rubbing alcohol to help with the smoothing process, especially with Monster Clay.

HAIR AND FUR

There are several techniques that can be used when adding hair and fur to the body of your creature. We will review both long and short fur as well as adding long hair or manes.

∼ DEMONSTRATION
MANES

1 Begin by rolling out the individual clumps of hair. The clumps should be wider at the base and tapered at the tips. They also should be varied in size.

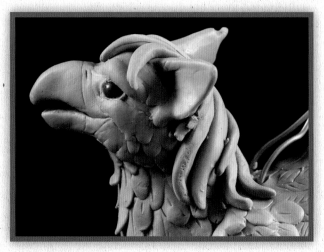

2 Attach the individual clumps to the head. Manes normally thin out as they approach the brow, but thicken around the back of the head and neck. Be sure to add in some bangs using thin strips of clay.

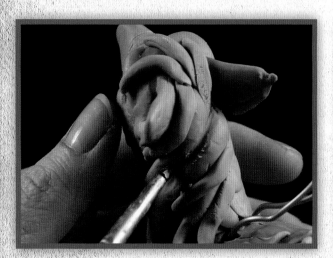

3 Use a rubber tool to smooth in the clumps. Run the tool between the shapes, pressing the seam together. Don't blend it away completely though. As with muscles, you want to still have some definition between the clumps of hair.

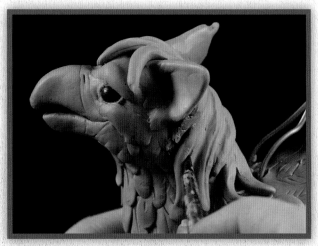

4 Using your rubber tool, draw in some splits and separations in the clumps, starting to give the appearance of hairs. These splits should taper as they approach the tip of each clump of hair. Areas like the bangs may not need these larger splits.

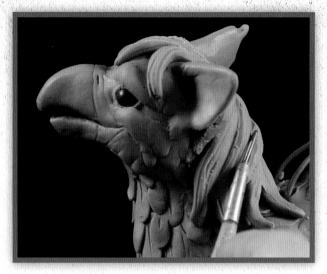 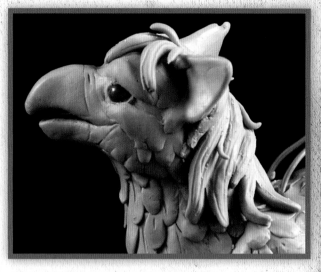

5 Using a metal detail tool, draw in some fine hair detail. Be selective about this and don't draw in every individual hair. Think about adding more line work in the larger hair clumps while the thinner areas of the hair show less detail.

6 Using thin, tapered strips of clay, create some stray hairs to add a little character to the mane.

FIELD NOTE

Be sure to check out what manes look like between different animals. I modeled this particular mane after a horse, but you can also look at animals like lions, hyenas and maned wolves.

Visit **www.impact-books.com/fantasy-creatures-in-clay** for more amazing bonus features!

85

SHORT FUR

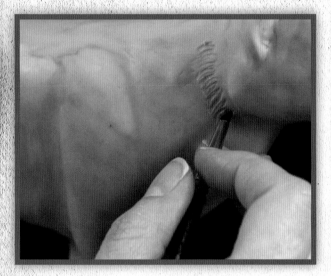

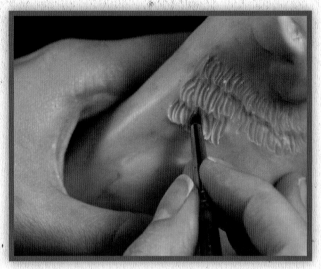

1 Create individual hairs using a rubber tool. This tool will give soft, natural edges to your strokes. With each stroke, pull away with the tool to give the illusion of hair growing out of the skin rather than lying flat on top of it. When creating short fur, be sure to follow the flow of the muscles below it.

2 Pull out more fur in layers, making each layer under the last one you created. This will add to the appearance that the hair is growing out of the skin.

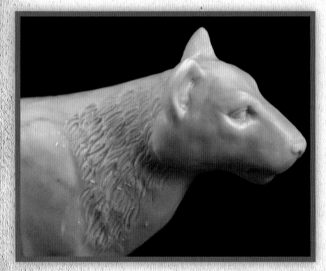

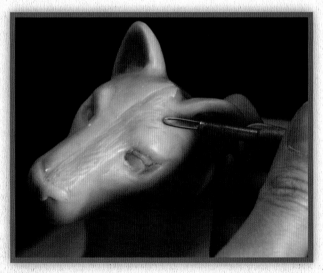

3 Once the texture is complete, go back and add some irregularity. Smooth some of the hairs together; make a few that are longer and some that go in different directions.

4 For even shorter fur, such as hairs around the face and paws, use a fine metal tool to draw these on. Go a little more shallow with your strokes on this fine hair. Use the same methods as seen in step 3 to add irregularity.

LONG FUR

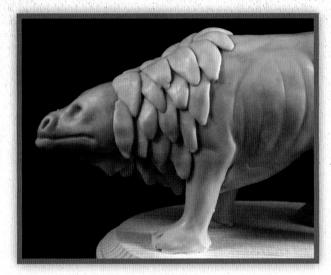

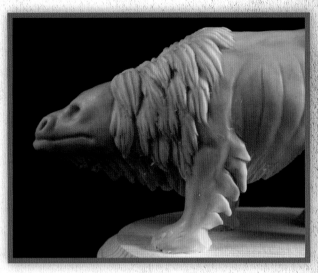

1 Start by creating overlapping triangular shapes where you want the fur to lie. Here I started with the fur under the neck and worked my way up to the back of the neck so the fur was properly layered. Make sure the fur follows the flow of the muscles and takes gravity into account. Unless in a dynamic pose, long fur will droop downwards.

2 Tool in large strokes to break up the clumps of hair into separate strands. Blend some of the pieces together and leave some defined. Vary the pressure and thickness of your strokes for a more natural look.

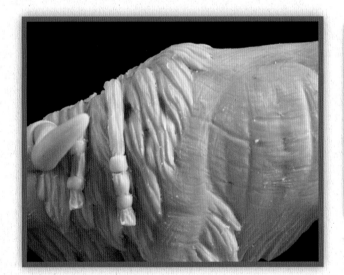

FIELD NOTE

In the natural world, long hair normally grows along the underside, around the neck and on the backsides of the limbs. Reference is invaluable when creating realistic fur and hair.

3 Using a metal detail tool, add in the fine hairs. Go back and blend some of the hairs together to add variety. Using the same techniques, you can also add in braids or other hair adornments as shown here.

SCULPTING THE BODY

Body coverings like scales, feathers, and skin will add a lot of depth to your piece. Work to keep these patterns natural by following the flow of the muscles as well as adding variety in the textures. We will also discuss how to sculpt feathered wings as well as adding detail to bat wings.

∾ DEMONSTRATION

SCALES

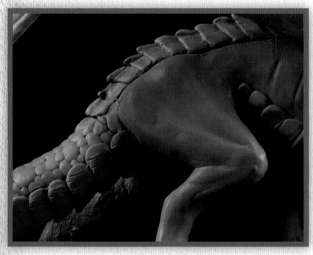

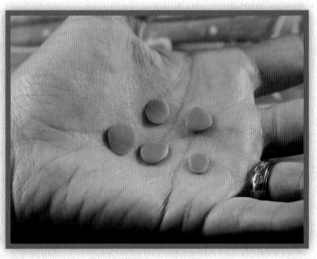

1 There is no quick and easy method when creating individually sculpted scales. However, this is a method I use to create believable scales that conform to the anatomy and show variety. This will be demonstrated on the right hind leg of this dragon character.

2 First, create a few large scales. They should be as flat as possible and mimic the desired scale shapes. Try to add variation by modifying the shape slightly between each scale created.

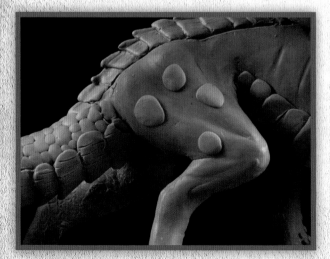

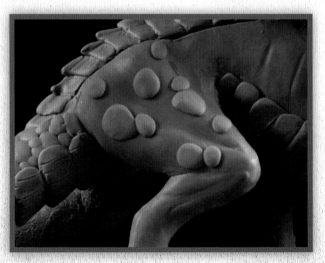

3 Lay the large scales onto the leg, keeping them spaced out over the thigh muscles.

4 Create another group of scales a bit smaller than the last. Place them onto the leg. Let a few touch the larger scales from the last step, while others are on their own.

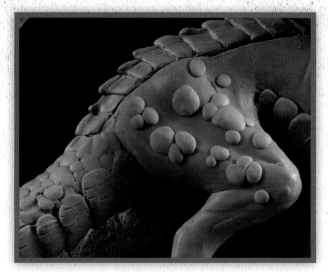

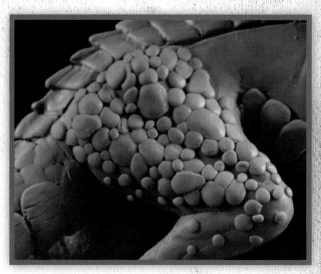

5 Create a third set of scales, again just a touch smaller than the last. Place them onto the leg using the same variety method as in the last step. Let some of the scales in this set touch each other and make sure you are evenly covering the area of the leg.

6 Continue creating more scales, using the same methods described on the previous page. Keep working smaller until the leg is covered with scales. As the scales approach the knee and edges of the thigh, they should start dissipating.

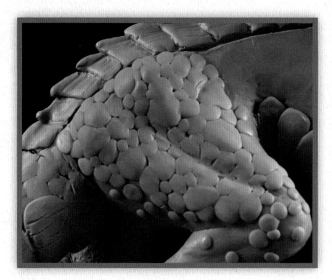

7 When you are done laying in the scales, press and smooth them with your hands to allow them to better conform to the muscle, to get rid of the bubbly appearance and add some variety in the seams between the scales. You can go back with a metal detail tool to deepen and define some of the seams if desired.

8 Scales are often smaller as they move below the knee and can be tooled in using a small metal tool. Use a circular motion and take your time.
 Variety can be added by laying in a few tiny pieces of clay over the top of some of the scales created by the tool. Not every scale needs to be defined; some areas can just have hints of texture as with the toes in this piece.

Visit **www.impact-books.com/fantasy-creatures-in-clay** for more amazing bonus features!

89

FEATHERS

Like scales, there is no quick and easy method to create feathers. However, there are a few points that you can follow to create believable feathers. For this example, we will focus on the chest and shoulder area and you'll want to start with a relatively smooth surface that shows anatomy.

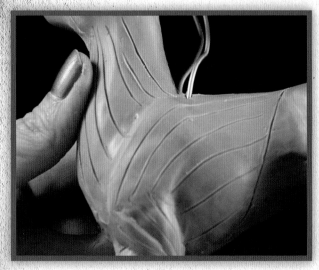

1 A key to creating a realistic flow to the feathers is placing them so they follow the flow of the form below them. Draw guidelines to plan out in what overall direction the feathers will flow on the different areas of the upper body.

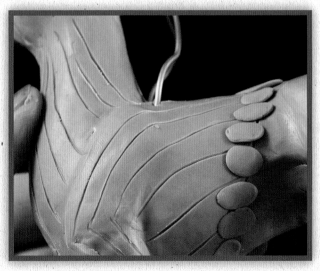

2 Individually create flattened ovals of slightly varying size and shape. Lay them into place on your sculpture, starting with the bottom-most layer. Since I am going to have the feathers stop at the waistline, this is where I created my first layer of feathers.

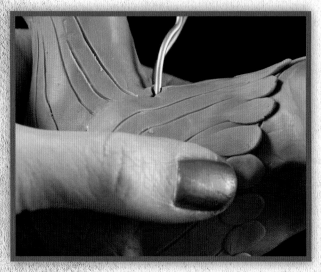

3 Smooth in each feather where it attaches to the body, leaving definition at the tips and seams. This will thin out the feathers a bit, giving way for the next layer.

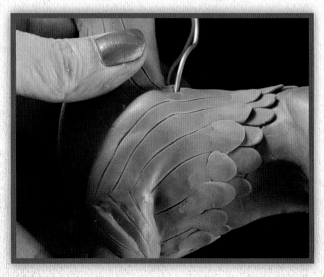

4 Create a second layer over the top of the first. Be sure to offset this layer slightly so the tips of the feathers don't line up. This will make it look natural.

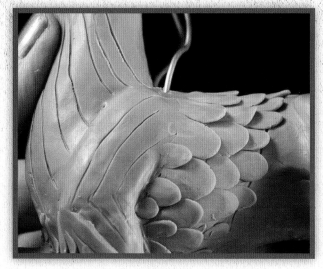

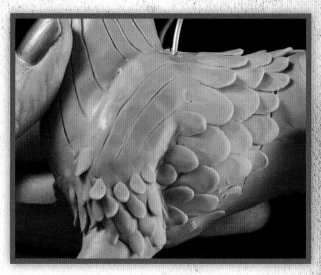

5 Continue to create overlapping layers of feathers, smoothing them in as you go along. Once you hit an area like the shoulder here, start a new group of feathers to keep the proper flow.

6 Here, I have started to layer smaller feathers around the elbow and upper arm. These feathers will move upwards along the shoulder blade rather than back along the rib cage as in the previous steps.

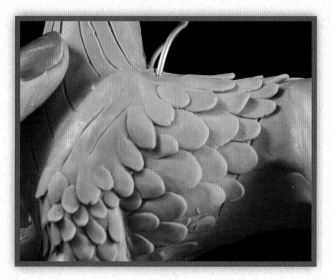

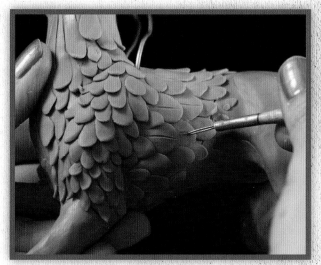

7 As I move up the shoulder, I start to add more feathers to the torso where the shoulder connects. The feathers are changing direction here, and it is important to keep that change gradual.

8 Finish placing all the feathers, then tool in the veining details, starting with the center shaft. I use my small wire loop tool for this. I start at the base of the feather and draw towards the tip. The line gradually grows thinner before it stops just shy of the tip.

Visit **www.impact-books.com/fantasy-creatures-in-clay** for more amazing bonus features!

91

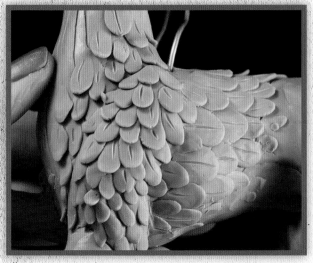

9 I don't draw the center vein on all of the feathers. I focus mainly on the larger feathers and a random few of the smaller ones. With meticulous details like feather veining, sometimes less is more. Sculpting every vein of every feather will make the piece look very busy and unnatural. Our eyes don't perceive that level of detail in real life even though that level of detail is there.

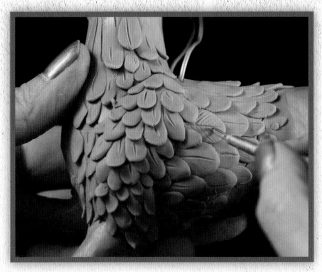

10 Now it is time to sculpt some of the barbs on the feathers. These lines should grow diagonally from the center, pointing towards the tip of the feather. Again, you don't want to draw every single barb. Try varying the thickness and spacing of the lines.

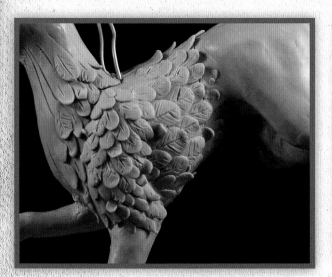

11 Once I have added enough detail, I go back and curl a few feathers at the tip slightly to get a better feeling of motion. Notice that not every feather has the same detail level.

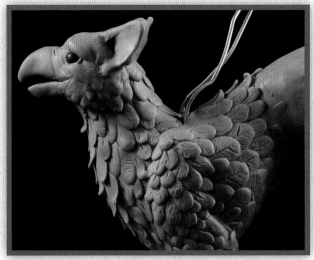

12 This image shows the finished feather work. Notice that some of the feathers are poofing up a bit on the front of the neck and chest, helping to break up an otherwise clean curve. The feathers on the cheek and face were done last. This creates an overlap that helps define the jawline.

HIDE

If feathers or scales are not a part of the character you want to make,
try using a normal leatherlike hide.

1 Using a rubber tool, press folds into the skin.
Start with the deepest folds first and then
work your way towards the smaller ones.
Use varying pressures to achieve a range of
depths in the wrinkles.

2 Make sure some wrinkles intersect and touch
each other while others dissipate into the skin.
Try sweeping the tool in several directions
rather than making all your strokes straight up
and down.

3 All wrinkles and folds should follow the
flow of the muscle. They will also change
direction if the muscle is tense or relaxed.
Also take into account gravity; wrinkles will
gravitate downwards.

4 Continue layering the wrinkles, slowly building
up to the finer details. Some of the initial strokes
can be given a second or third pass with the tool
to get a deeper effect. Don't overdo the deep
wrinkles or the natural feel may be lost.

5 Begin adding in fine details with a metal tool. Short, perpendicular lines can be added between the folds, as well as tiny wrinkles. Once you are done, brush the sculpture with rubbing alcohol to smooth out the imperfections.

6 Once the alcohol is dried, you can go back in and add the finest details. These are details that the rubbing alcohol would rub out. I like to add in small dimples to give the illusion of pores.

7 All the wrinkles and dimples combine to make a realistic hide for your character.

FEATHERED WINGS

Feathered wings are one of the most complex and time-consuming areas to sculpt. To create accurate wings, knowledge of wing anatomy is absolutely crucial. Wing and feather shapes vary from bird to bird, but wings generally follow the same layout.

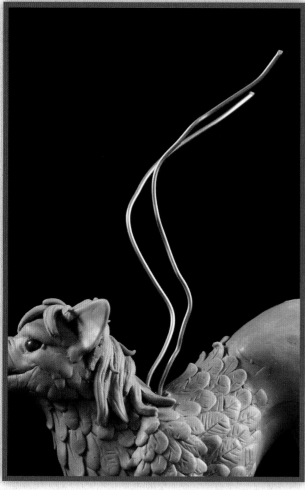

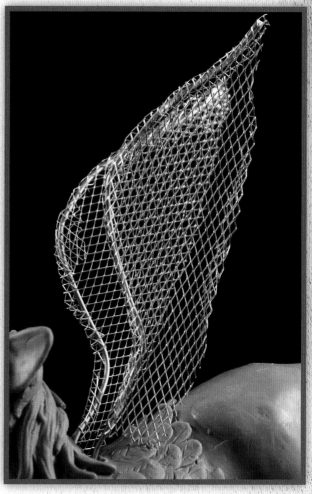

1 We start with the bare wire armature for the wings. This wire simulates the skeletal structure of a bird's wing.

2 A piece of wire mesh is used to flesh out the area of the wing that the coverts occupy. I usually go conservative here so the wing doesn't become too big once I start putting clay on the mesh.

Visit **www.impact-books.com/fantasy-creatures-in-clay** for more amazing bonus features!

95

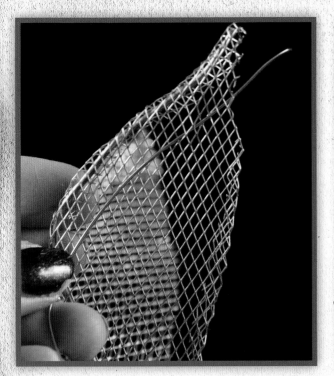

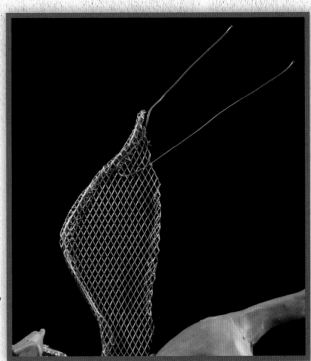

3 The next step is to create the armature for the primary feathers. I am decreasing the number of feathers for ease of explanation. I start by cutting a length of thin gauge wire that is long enough for the outermost two primary feathers combined. I will weave the wire through the mesh, so there needs to be a little extra length to compensate for that.

4 The wire is bent into a U shape before being woven through the mesh. I usually start weaving about an inch away from the edge of the mesh, going in and out several times until the wire is secure. The wires represent the centers of the feathers, so make sure they are in the proper position with enough space between each one.

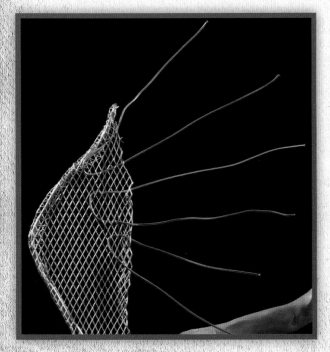

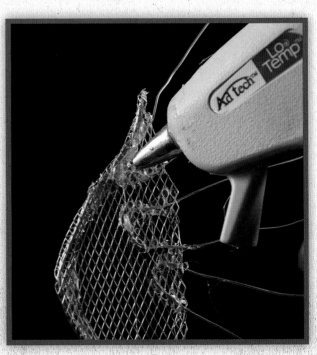

5 Here is the wing after weaving in three wires, representing six primary feathers.

6 The wires are shifting around slightly, so I glue them into place using a hot glue gun.

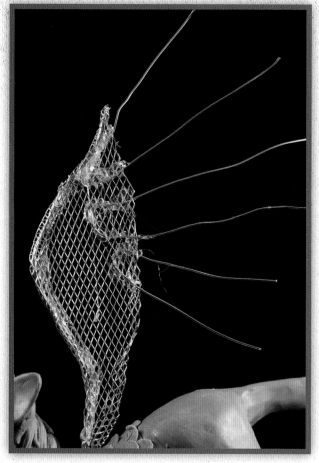

8 Using a pasta machine on thickness setting #2, I rolled out a sheet of clay and drew a variety of secondary feathers. Cut them out, then smooth out any rough edges.

7 This is the finished wing armature.

FIELD NOTE

Below are two drawings, representing both sides of a bird's wing. It's important to understand the real life structure of the part you're trying to reconstruct in clay form. This includes knowing how to locate the primaries, secondaries and other feather groupings on the wing.

Dorsal
Top or outside of the wing.

Ventral
Bottom or underside of the wing.

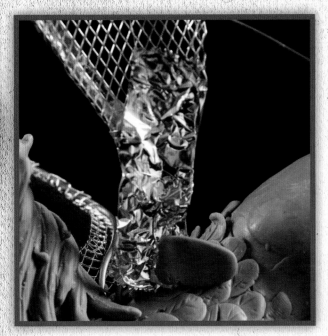

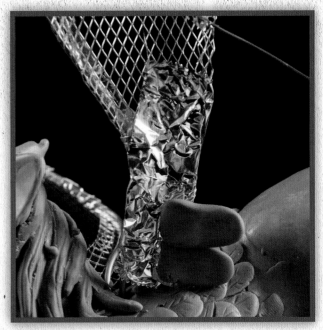

9 When laying down feathers on the wing, be sure to use the proper stacking order. Since I am currently sculpting the ventral or bottom side of this wing, I want to start with the secondary feather that is closest to the body. This is the feather that is at the bottom of the stacking order. I can now layer all feathers consecutively atop this one.

10 The next secondary feather is placed on the wing, slightly overlapping the first. Notice that this feather is just a touch longer, beginning the arch shape that the feathers will form when complete.

FIELD NOTE

If you don't leave yourself enough space with the wire mesh, add a bit of foil to the base of the wing armature before starting to lay in the feathers.

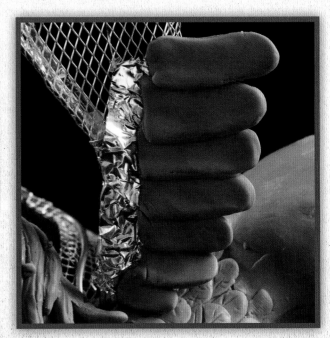

11 The rest of the secondary feathers are laid into place on the wing, each slightly longer than the one before it. Notice that the arc is now starting to show at the edge of the wing.

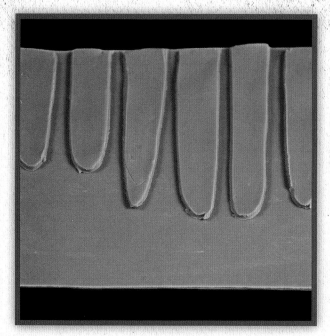

12 To create the primary feathers, I rolled out a sheet of clay on the #3 setting and drew them out in the same manner as I did the secondaries.

After the feathers are cut out, they are laid atop a similar sheet of clay to be used as a stencil for the second set. These two sets of feathers will be used in pairs to create the primaries.

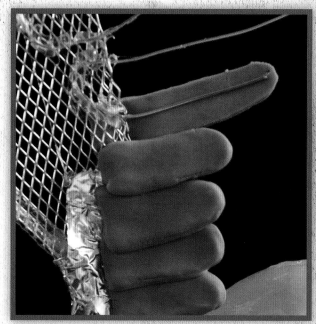

13 The primary feathers are created one half at a time. I like to start with the back half first, laying it into place on the wing. As with the secondary feathers, primary feathers slightly overlap the previously made feathers and are just a touch longer than the last.

Be certain that the wire from the armature is mostly centered on the feather shape. If you have to bend the wire a bit to get it to line up right, that is fine.

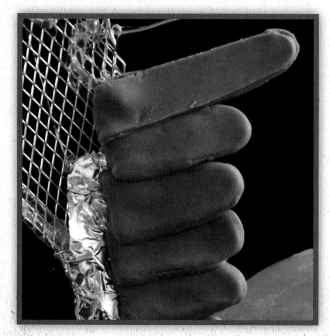

14 Lay the second half of the feather over the first, lining up the edges. Gently press into place. Be sure not to press too hard or the armature wire could poke through.

FIELD NOTE

If you are having a hard time separating the two halves of your feathers after cutting them out, try a little cornstarch or baby powder between the layers of clay.

Visit **www.impact-books.com/fantasy-creatures-in-clay** for more amazing bonus features!

99

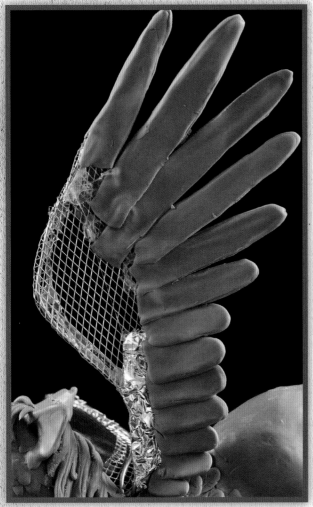

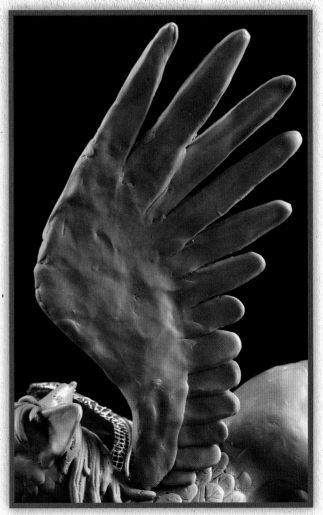

15 As you are creating the primary feathers, pinch and smooth along the edges of each one to close up the seams that form when placing the two halves together. When doing so, be sure to avoid the armature wire in the center.

16 Before laying in the covert feathers, I cover the rest of the wire mesh with a thin, even layer of clay. I smooth out all the major lumps, but I don't worry about making it too perfect since it will be covered with feathers in just a bit.

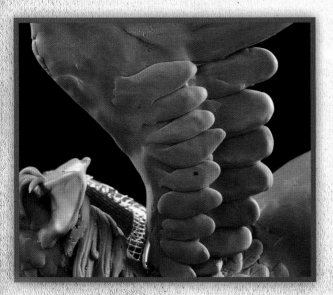

17 The covert feathers are laid down in the same fashion as the secondaries. The coverts should overlap each other as well as the primary and secondary feathers that sit underneath. Make sure that the edges of the feathers don't line up. The tips of the coverts should point at the seams between the primary and secondary feathers.

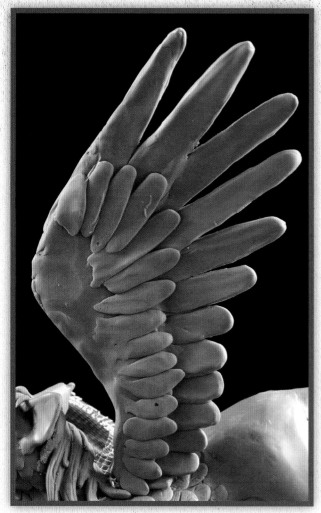

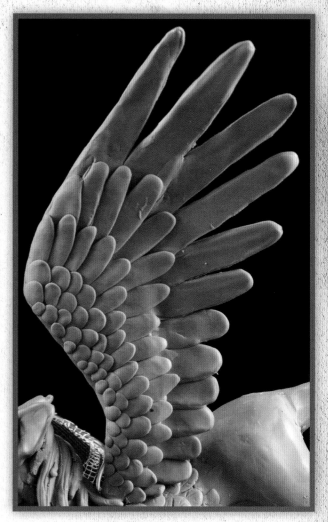

18 The photo shows the first layer of covert feathers complete. Notice that they follow the same arcing seen in the primary and secondary feathers.

19 The last few photos have shown the progression of the covert feathers. They become gradually smaller as they move towards the top edge of the wing. They also begin to round out and look similar to the body feathers that we sculpted earlier in the chapter. This is a time-consuming, meticulous process, but as you can seen step 24, the final look is worth the work.

Visit **www.impact-books.com/fantasy-creatures-in-clay** for more amazing bonus features!

101

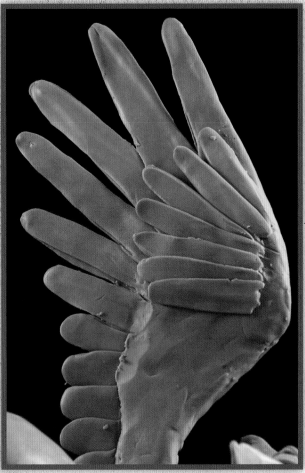

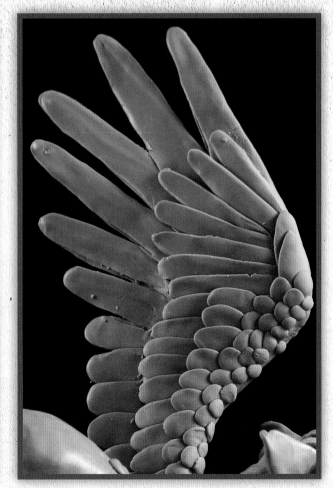

20 Now the dorsal covert feathers need to be sculpted. This time, the stacking order of the feathers is reversed. Therefore, the first feather that is laid down is on the outside edge of the wing. The feathers continue to be laid down in the same fashion as discussed with the ventral side of the wing. However, the pattern of how the feathers are arranged is a bit different.

21 Here you can see the progression of covert feathers being laid down onto the dorsal side of the wing. Again, the layout is slightly different than what was done on the opposite side of the wing, but the process is exactly the same. Remember to add the alular quills on this side of the wing.

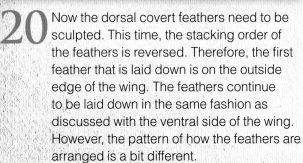

22 Finally, it is time to get some fine detail on the wings. Start by creating the main center veins on the feathers. On the primaries, you will want to use two parallel lines to represent the vein so it appears thicker. You can also remove some of the clay on either side of the vein to give it a slightly raised appearance. Make sure not to carve large veins like this on all the feathers or the wing will start looking cluttered and overly detailed. When texturing a wing, it is definitely a case of less is more.

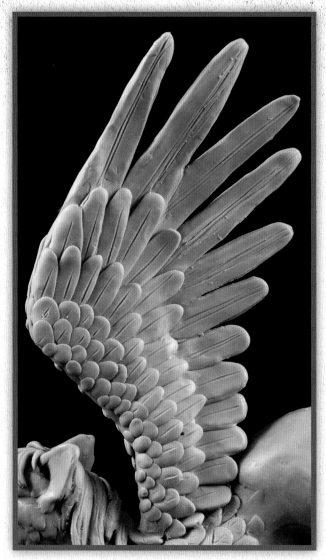

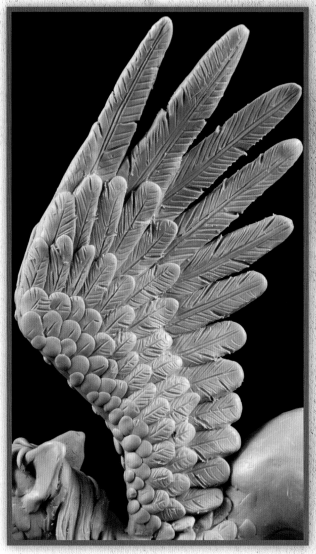

23 The photo shows the full ventral wing with all of the center veins sculpted in. Notice that as the feathers grow smaller, the veins become thinner and less noticeable. Some of the smaller covert feathers don't have the center veins sculpted at all. Again, this is very similar to the approach used when sculpting the body feathers earlier in the chapter.

24 The final touch is to add barbs on the individual feathers. The large primary feathers are going to show more detail than the smaller secondary and covert feathers. The smallest feathers likely won't show any fine detail at all. Remember to add some larger splits and irregularities as seen here. Repeat this entire detailing process for the dorsal side, and you will have a finished, detailed wing.

Visit **www.impact-books.com/fantasy-creatures-in-clay** for more amazing bonus features!

103

WING MEMBRANES

We haven't really touched on the dragon's wings since the armature stage, but this is a perfect example of creating wings without the necessity of having feathers.

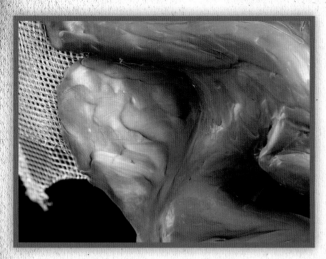

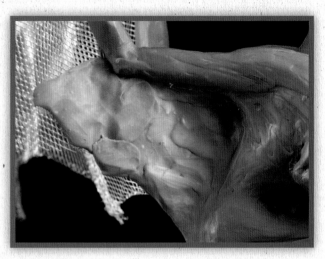

1 The membranes first need to be laid in using very thin pieces of clay. Press the clay onto the wire mesh, making sure it is securely in place and free of lumps. I like to attach the membrane behind the hip, similar to a bat. This helps it appear as though the wings can carry the dragon's full weight.

2 Continue building up the membranes using overlapping pieces of clay, smoothing them together as you go along. Keep the membrane as thin and even as possible. You can use a pasta machine to help with this.

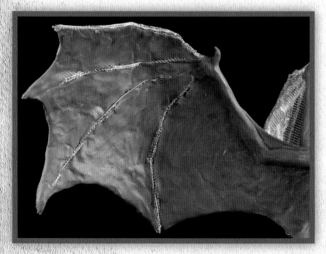

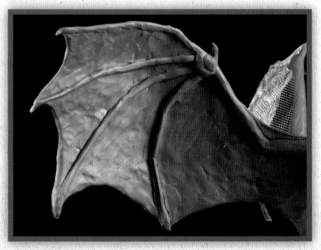

3 This photo shows the entire underside of the wing membrane laid in. Be sure to wrap the clay around the edges of the membranes, taking care not to cut yourself on the sharp mesh. Also notice the added membrane centered around the inside of the elbow, attaching the forearm to the upper arm, like a bat's.

4 Using thin and tapered tubes of clay, lay in the wing fingers on top of the membranes. Build up the palm around the thumb of the wing as well. It should resemble the structure of a hand.

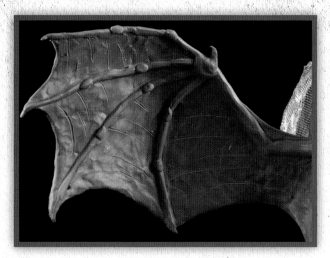

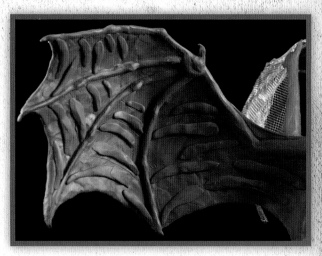

5 Add in some joints to the wing fingers using balls of clay. Again, the structure should be similar to that of a hand, so the joints should lie in an arc just like knuckles.

Begin laying out the folds and wrinkles in the membranes by marking their placement with a fine line tool.

6 Smooth the joints into the wing fingers and add some mass to the folds of the wings using thin strips of clay. I have bulked them out here more than I need to as I will be shaving them down in the next step.

FIELD NOTE

Referencing bat wings can help a lot when sculpting folds and wrinkles.

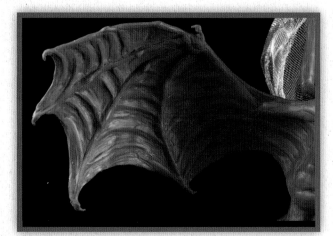

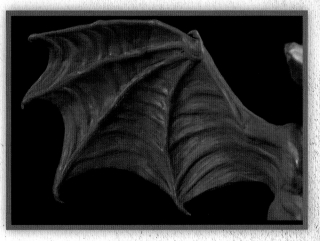

7 The strips of clay are carefully shaved down and smoothed into the wing membrane. I also shaved down the clay between the folds to add further depth. Clay was added where the membranes meet the wing fingers. This gives the impression of skin stretching across bone. Finally, some claws were added to the tips of the wing fingers.

8 This photo shows the final smoothed wing. If desired, fine details and textures can be sculpted over the top of the wing surface. You can also cut out tears or holes using an craft knife.

Visit **www.impact-books.com/fantasy-creatures-in-clay** for more amazing bonus features!

105

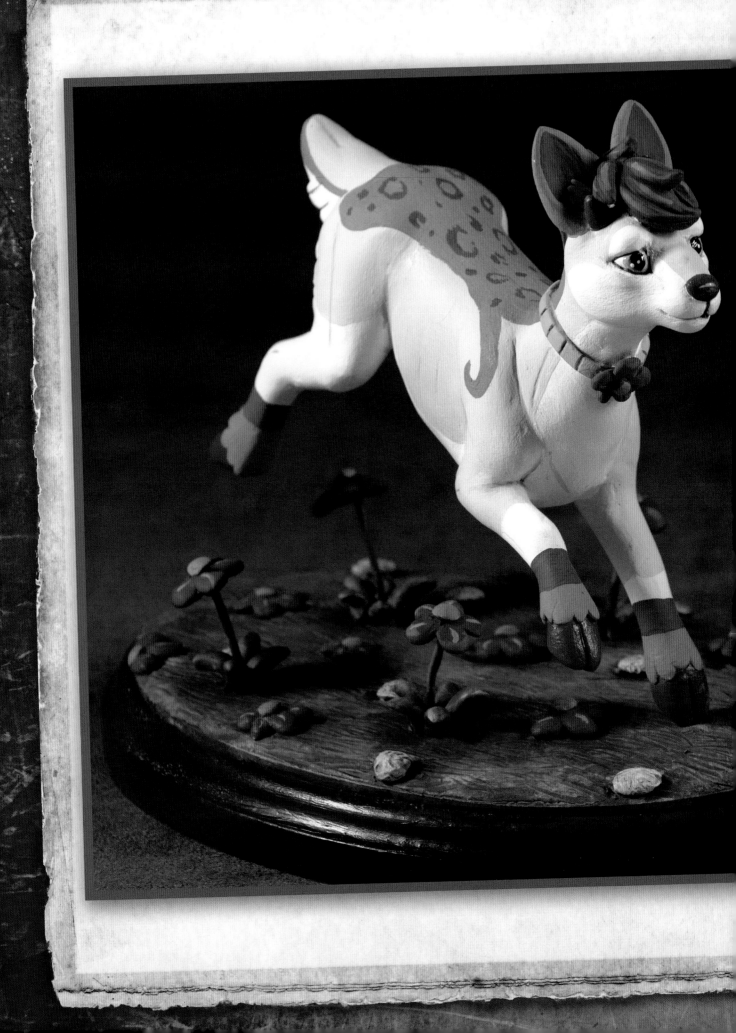

ACCESSORIES AND ENVIRONMENTS

Your character is now starting to look pretty finished. All of the anatomy and textures are in place, and it is posed dynamically. However, it is lacking details that tell a story about who your character is. Where does it live? What does it do? Employing the use of accessories and environments is crucial to creating sculptures that have an interesting character. Environments shouldn't be an afterthought but should be an extension of your character. Maybe your character is an underwater sea creature, and you want an environment that appears to be the ocean floor. Maybe your character is a battered old warrior who still wears his old armor and roams the desert. Or maybe you have a character that hunts its prey in the depths of the rain forest. It is important to think about these aspects so you can sculpt accordingly.

Environments and accessories don't need to be overly complex or detailed. After all, you don't want them to outshine the character itself. However, they should complement and enhance the character's appearance. I will briefly discuss some methods for creating and attaching accessories. Then, I will discuss how to detail a variety of environments. I will talk about both natural and man-made environments and how to create different textures within each. Some of these topics may seem glossed over; I could easily turn this chapter into an entire book in itself. However, I have tried to cover what I think are the most important topics. Try to take what you learn in this chapter and apply it to creating things I haven't directly discussed. At this point, you should be pretty good at solving some sculpting problems, so put that to good use here.

ADDING JEWELRY OR ARMOR

It's important to create individual pieces of armor or jewelry separate from the main sculpture. I've used pure Sculpey Firm here because it is good at holding a rigid shape. I hold the pieces up against the main sculpture during their creation to ensure proper sizing.

1 For this lioness character, I wanted to give her a royal appearance. I chose to make a tiara as well as a matching neck piece to help with this look. I kept nice flowing edges while creating the pieces so they look delicate.

2 Create raised edges by rolling out a long, thin piece of clay to go around the edge of the piece. You can create all sorts of designs using this method. Be sure to experiment.

3 Lay the pieces onto the sculpture and wrap them as necessary. Apply slight pressure so the pieces will adhere.

4 You can now add fine details such as jewels and carvings. For these jewels, I used flattened balls of clay.

ADDING CLOTH ACCESSORIES

Since this book focuses on creatures, I won't discuss how to sculpt clothing. However, you may want to add some small cloth accessories such as a scarf or cape. Employing wire mesh as well as a pasta machine will yield the best results.

1 Using a pasta machine on the #3 thickness setting, I roll out a long, narrow sheet of clay and trim the edges carefully with a craft knife.

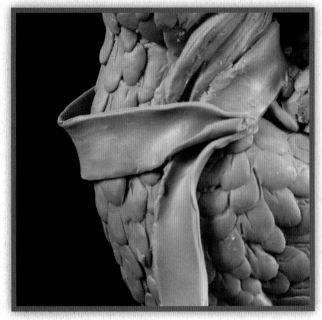

2 The scarf shape is next wrapped around the neck of the character. The two ends should cross over where the knot will be. I begin to add shape to the scarf by pinching where the two parts come together in a knot. I also add a little slack near the front of the neck so it doesn't look like the scarf is choking him.

3 Now I will create the other end of the scarf, which will trail behind the character. Since this cloth will be suspended and flowing in midair, wire mesh is used for support. I start by cutting out a piece of mesh in the shape of the scarf.

Visit **www.impact-books.com/fantasy-creatures-in-clay** for more amazing bonus features!

109

4 I then cover it with a thin layer of clay on both sides and smooth it out. At the end that will be attached to the rest of the sculpture, I leave a small bit of mesh showing to use as an anchor. Pinching this mesh together slightly will make it easier to insert into the clay sculpture.

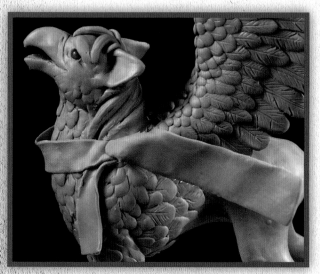

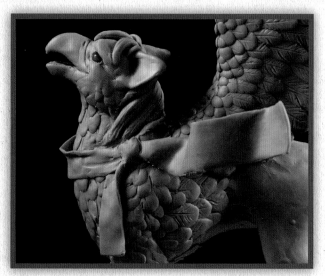

5 The mesh is inserted into the sculpture at the point where the knot will be on the scarf. Make sure it is securely embedded into the clay. Smooth some of the surrounding clay together with the newly added piece to help anchor it in place.

6 A knot is added to the scarf using a small ball of clay. This should obscure the area where all of the previously formed pieces of clay came together. You are now free to add wrinkles or other details on top of this. The trailing scarf end was bent into a swoop to make it appear to be blowing in the wind. I also allowed it to slightly touch the body to help add stability.

FIELD NOTE

If this is a larger piece of cloth such as a cape, you may need to use wire to support the weight and keep the cloth in shape.

PREPARING THE BASE

In this demonstration, I will sculpt a base that is completely separated
from the character. I have done this for better visibility of detail work.
Be sure the wood is dry if you plan to bake it later.

1 Before adding detail atop your wood base, first
cover it with a layer of clay. Make certain that
you have sanded down any imperfections in the
wood before doing this.

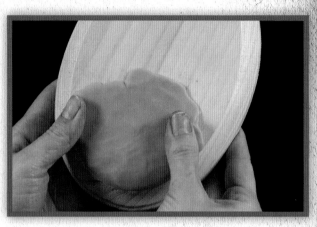

2 Using pieces of flattened clay, I cover the entire
top surface of the base, smoothing as I go along.

3 Once the base is completely covered in clay, I
smooth it all together until the entire surface is
as smooth and even as possible. I have covered
only the top raised part of the wood base, not
the rim.

4 The baked character is placed atop the base for
positioning. I gently press the figure into the clay
to form an impression. I'll use this as reference
when sculpting the environment.

FIELD NOTE

When covering a base in which the character is attached via the
armature, be certain to cover the wire/nail attachment point
entirely. This will give the illusion that the character is standing in
the environment rather than atop a wood base. Be certain to keep
the clay smooth around the attachment point.

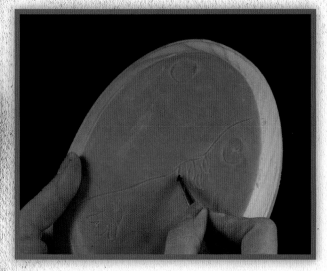

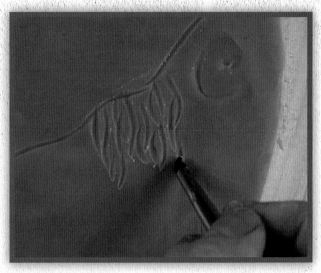

5 Here, I have decided the layout of my base. I created a light dividing line, showing where I want different textures to fall. Implementing more than one texture on the base really adds interest to the piece, even more so when it contrasts to the textures seen within the character.

6 I begin this base with a simple grass texture. The way I sculpt grass is very similar to the way I sculpt fur: with overlapping layers and variety in the strokes. I start here with a rubber tool, drawing individual blades. Though the blades should move in the same general direction, they shouldn't all look exactly the same.

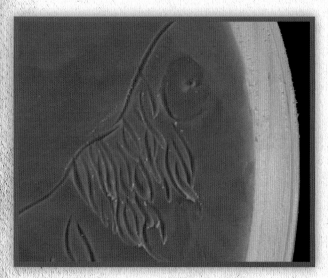

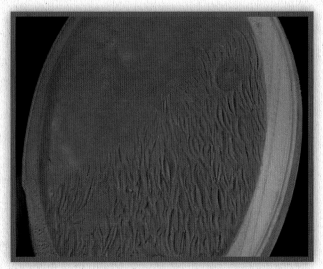

7 Just like fur, some of the strokes are deeper than others. They curve and overlap each other rather than move straight across the surface of the base. This will give the impression of flowing grass.

8 The photo shows the grass after a little refinement, especially along the centerline where the grass meets with the dirt. The texture tapers off rather than abruptly stopping.

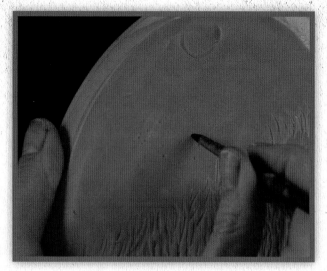

9 Dirt or sand texture can easily be created with the use of a rubber tool. This particular tool has a hard, sharp tip that is perfect for creating dimples. Holding the tool at a 90 degree angle to the base, I dot the surface randomly, varying the pressure to create different depths and sizes of the dimples.

10 Larger pieces of dirt and sand or even tiny pebbles can be created using tiny balls of clay. This adds nice contrast in texture to the existing dimples. It is important to keep the placement of these balls random so it looks natural. Clumping a few of the pebbles together now and then adds a nice touch as well.

FIELD NOTE

It may not look like much just yet, but the indentations will be very handy when it comes time to paint; they will add variety in color and value to our little patch of dirt.

11 Next up, we have some large rocks. Like the pebbles, these have been placed in a fairly random manner atop the dirt texture. They also vary in size and are paired together in a few spots.

12 To create the hard edges of the rocks, I use a metal ribbon tool. Starting with the top of the rock, I gently scrape away the clay until a smooth surface forms.

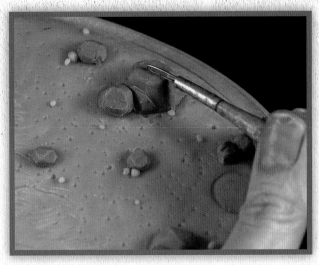

13 I next move onto the side of the rock and repeat the same technique I used for the top of the rock. Notice the hard edge that has formed between the two sides. These edges are part of what will help the rock look rigid, so be sure not to smooth them out too much. At the same time, you don't want the edges to be so sharp that the rocks appear to be man-made.

14 To add cracks and splits in the rocks, I use a fine metal tool. I start with the larger splits and work my way to the smaller cracks.

FIELD NOTE

The pattern and layout of cracks in rocks is very similar to the way that branches of a tree grow or how veins in a leaf lie.

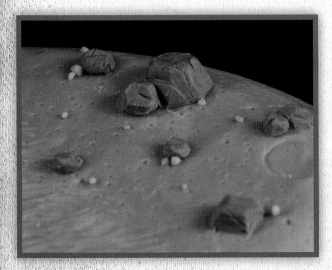

15 Finish the remaining rocks.

16 Next up, some tree roots are added to the base using tapered strips of clay. There is an illusion of roots weaving in and out of the ground created by strategically placing the strips of clay on the base. The strips of clay grow smaller as they move away from the large main root.

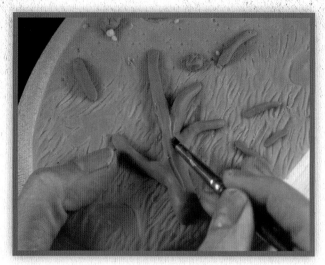

17 Texture is created on the roots using a rubber tool. Strokes are carved in a flowing motion, following the direction that the root is growing. Smaller, more shallow strokes are used on the smaller areas of the roots.

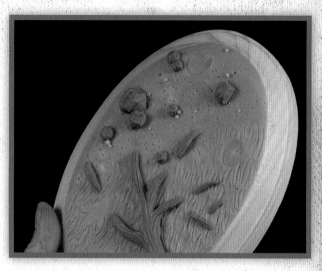

18 Add texture to all the roots.

19 I add a few upright blades of grass as accents. I place them in both the grassy area as well as in the dirt.

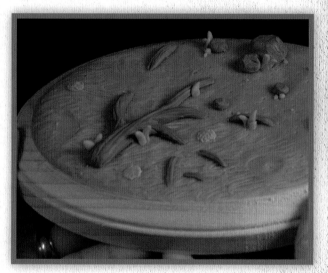

20 Add a few dandelions in the grass to break up the texture a bit, and the base is ready for the character to be placed on top.

FIELD NOTE

Notice that I place the blades of grass only in areas where they can be supported by other elements of the environment. Blades of glass are so fragile they would otherwise break if not supported.

Visit **www.impact-books.com/fantasy-creatures-in-clay** for more amazing bonus features!

115

GEOMETRIC/MAN-MADE BASE

Creating geometric shapes for man-made environments can be a bit challenging. Since clay is soft by nature, hard edges and sharp angles can be more difficult to attain as opposed to organic forms. Remember, you can always put your clay in the freezer if you need a little assistance in keeping your edges smooth and crisp.

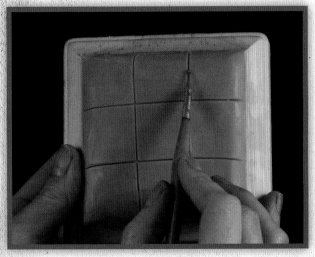

1 I first lay out a grid of tiles, marking in evenly spaced perpendicular lines using my metal detail tool. The lines are drawn lightly as a guide. I then run the tool over the lines several times until the line is clean and defined.

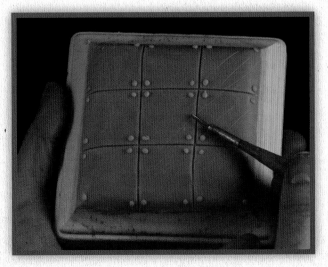

2 Rivets are placed using small discs of clay. I like to place rivets in all four corners of each metal plate. Scratch marks are lightly etched over the surface of the tiles. This gives the floor a worn or used look. Vary the direction of the lines and allow them to cross over one another at points.

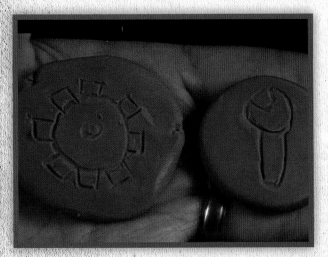

3 Let's add a few accessories to this scene. Using even sheets of clay, about ⅛" (3mm) thick, I draw out a gear and a wrench using my metal tool.

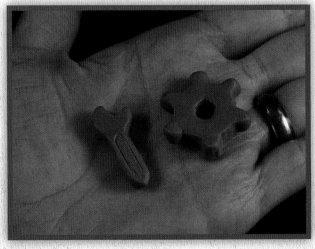

4 The shapes are cut out using a craft knife. Smooth and add any necessary details.

5 Next up, a crate will be added to the scene. I start with a rough cube of foil and cover it with clay. I stamp each side onto my work surface until it is fairly smooth and even on all sides.

6 Wooden planks are sketched in using my metal detail tool. Notice planks that frame each side of the box as well as planks that lie flat across the sides.

7 The frame planks are bulked out with more clay, and the edges are smoothed out using a metal ribbon tool. The grooves in between the planks are further defined using a metal detail tool.

8 Final textural details can now be added to the planks of wood. Wood grain is etched in with a metal tool, and small nails are added using discs of clay. Notice the stippling at the ends of the frame planks where the wood has been cut. Adding small details like this really helps add believability to your pieces.

FIELD NOTE

Since accessories like this are being created separately from the base rather than being sculpted directly on it, they will need to be attached to the base somehow. Simply laying them on the base during baking won't result in the accessories sticking; they will be easily separated once the baking is complete. So after baking and painting, I like to use Super Glue to attach loose accessories to the base or epoxy for larger pieces. This will ensure they are held in place. Additionally, waiting until the piece is finished before attaching will give you the freedom to sand and paint the accessories separately.

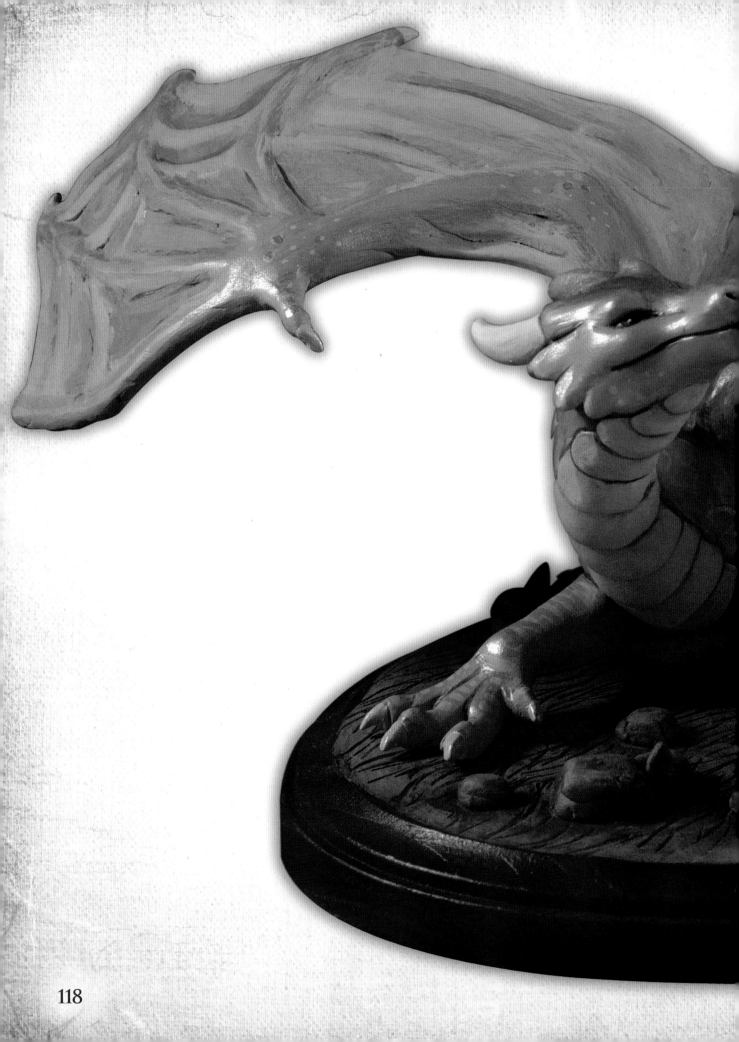

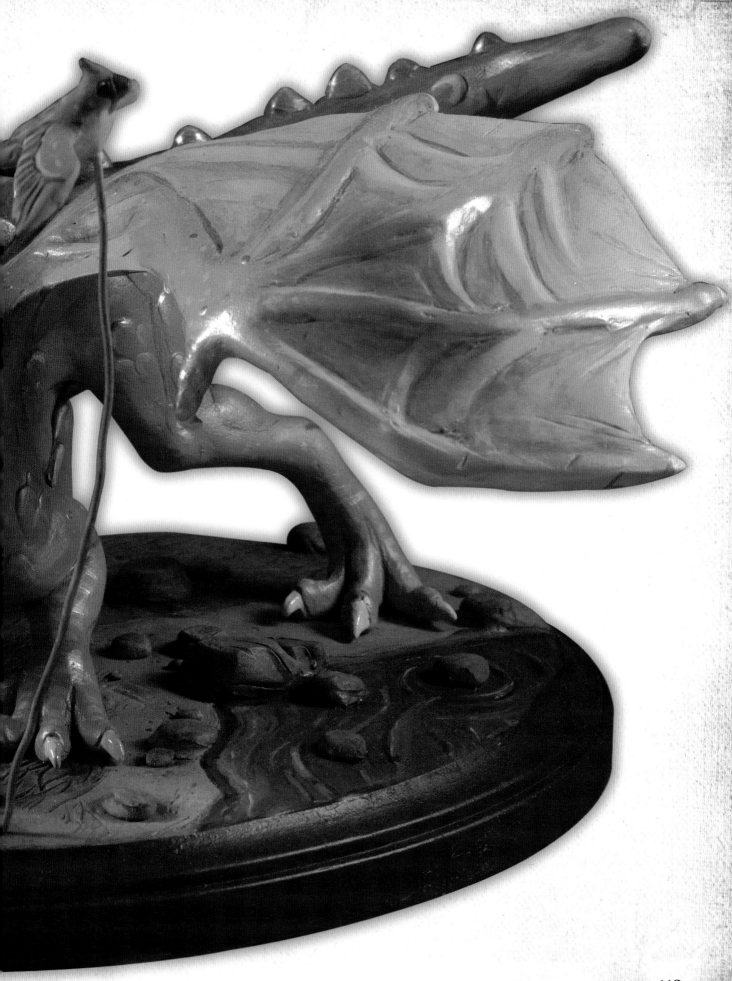

Visit **www.impact-books.com/fantasy-creatures-in-clay** for more amazing bonus features!

119

Chapter **Six**

FINISHING
TECHNIQUES

You've done so much work to make your sculpture look awesome, but there are still a few things to do before wrapping up your project. If you are working in Monster Clay, only a portion of this chapter will apply to your piece since you will not be baking your sculpture. The next few pages will discuss using rubbing alcohol; Monster Clay users will definitely want to read up on this final smoothing technique. However, if you are working in Sculpey, this entire chapter will apply to your piece. This is one of the shorter chapters, but it also contains a lot of information that is often overlooked by sculptors. It is very tempting to jump right into painting once you are done forming the clay. However, taking the time to add final polish to your piece will give it a very professional look.

FIELD NOTE

Note that the following pages discuss using 100 percent rubbing alcohol, which is intended only for use with Sculpey. For Monster Clay, I use a 50/50 mix of rubbing alcohol and myristate for smoothing. Use a metal or glass container to hold the mixture and cover any excess to avoid evaporation.

USING RUBBING ALCOHOL

Rubbing alcohol is an amazing finishing tool that can help to remove fingerprints, small imperfections and small clay particles. It is important not to overuse alcohol though because it will dry out the surface of the clay if too much is applied, causing the clay to crack. There are several different ways in which rubbing alcohol can be used, and I will describe them here.

∾ DEMONSTRATION

TEXTURED SURFACE

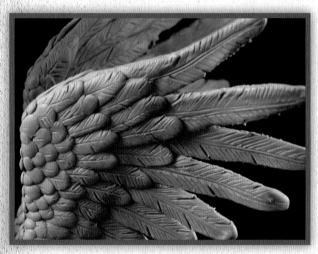

1 Textured surfaces like this feathered wing can benefit greatly from rubbing alcohol. Notice the small particles of clay along the edges of the primary feathers. These can be difficult to remove from the piece without damaging the delicate structure of the feathers. However, using a firm soft-bristled brush to apply rubbing alcohol will easily remove these annoying imperfections.

2 Dip your clean brush into the rubbing alcohol and allow the excess to drop off. Brush the rubbing alcohol along the textured surface. Use gentle, short strokes, making sure not to overwork any given area. Move on to a different spot once the area you are working on is smoothed.

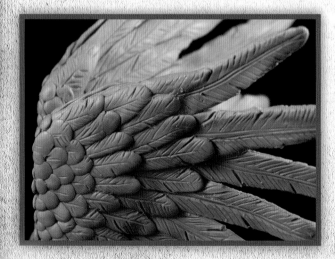

3 Notice that not only do the edges of the feathers look cleaner and smoother, the barb details of the feathers have been softened, giving it a more natural appearance.

FIELD NOTE

Be careful not to apply too much rubbing alcohol or you can wash away some of your fine details. It may be necessary to go back and retool some details after a rubbing alcohol application.

SMOOTH SURFACE

Smooth surfaces also respond very well to rubbing alcohol. However, a little more work is needed to get the full benefits as compared to a textured surface.

1 Here we see the hind leg of the hippogryph character. There are noticeable bumps and imperfections in the clay that I would like to get rid of.

2 As with the textured surface, rubbing alcohol is applied with a clean paintbrush. Once the area is covered with alcohol, I smooth it as much as possible with just my hands, working out the larger imperfections.

3 I use the metal barrel of a rubber tool to finish off the smoothing. This gives a fairly polished look and will help remove any remaining fingerprints.

4 If you compare the final smoothed leg to the photo in step 1, it is visibly smoother and more uniform.

FIELD NOTE

Have a paintbrush dedicated to rubbing alcohol to avoid contaminants like paint. Also, make sure to work quickly when smoothing. Once the alcohol dries, it won't be of any use to you.

LINES AND SEAMS

Rubbing alcohol can also be used to clean up line work or seams.

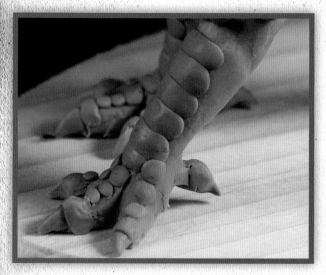

1 Locate a part of your sculpture that looks too bubbly or claylike. The scales on these legs are are just that, and I want harder lines between them.

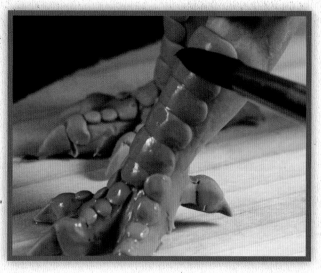

2 The alcohol is once again applied using a clean paintbrush. I take special care to press the brush into the seams to make sure the alcohol works its way in.

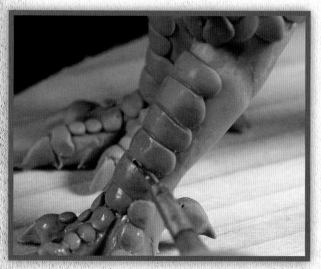

3 Using a fine line metal loop tool, I draw in new lines between the scales, drawing over the old ones. The rubbing alcohol softens the lines and cleans them up as I work. This is a great way to clean up ornate carvings or designs.

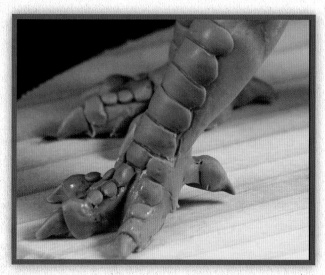

4 Though I still have further cleanup to do around the toes, the scales are looking much crisper and more defined.

BAKING THE SCULPTURE

Sculpey will bake in your home oven. As long as you follow the instructions on the Sculpey box, you shouldn't have any problems. However, I want to go over a few tips I have picked up over the years that aid in the baking process. Never exceed the 275° F (135° C) temperature when baking or you risk burning the sculpture and releasing toxic fumes.

I have heard rare cases of old ovens burning sculptures at the recommended temperature. If you are worried about a piece burning, try baking a test lump of Sculpey before baking your final piece. Do *not* microwave. Avoid using toaster ovens and absolutely *never* leave your oven unattended while baking a piece.

1 Before turning on the oven, remove all but one of the racks in your oven. You want to have enough clearance so the sculpture doesn't touch or come within less than 4" (10cm) of the upper heating element. If your oven has a lower heating element, place the rack so the sculpture is centered vertically.

2 After positioning the oven rack, close the oven and preheat to 275° F (135° C). While the oven is preheating, line a Pyrex baking dish with foil and place the sculpture in the dish. I have a set of Pyrex dedicated to Sculpey use, which I recommend. Sculpey is nontoxic, but it will also tarnish bakeware.

3 After the oven is preheated, place the dish and sculpture in the oven and center it on the rack. Close the oven and set a timer for twenty minutes. Unless you have an extremely thick piece of clay (over ½" [13mm]), this should be plenty of time to bake the piece all the way through.

4 Once the timer goes off, turn off the oven and crack the door open slightly. Allow the sculpture to cool for around fifteen minutes. The dish should be cool enough to pick up with your bare hand when the sculpture is ready to come out. Allowing the sculpture to slowly cool off in this manner will help prevent cracking from sudden temperature change.

5 Remove the sculpture and dish from the oven and allow them to cool completely on the counter. Do not handle the sculpture until it is fully cooled or you risk damaging it.

FIELD NOTE

Unfinished wood bases can be placed in the oven at this low temperature but beware. I have had some wood bases leak sap and make a complete mess. Make sure the wood you are using is dry to help prevent this.

SANDING TECHNIQUES

Sanding is a commonly overlooked and underrated aspect of sculpture. All of my Sculpey pieces get sanded to some degree, especially ones with a superclean, smooth finish. There is definitely a science and art to sanding, and it takes a lot of practice to understand the surface flow of your sculptures. However, once it is mastered, sanding is an invaluable part of your sculpting arsenal.

∾ DEMONSTRATION
TEXTURED SURFACE

1 Gently hold the sculpture in one hand. If your sculpture is attached to a base, I recommend holding it at the base if at all possible. Using your other hand, gently sand the surface of the sculpture with the sandpaper, moving in small overlapping circles.

2 Sand over the darker areas until they become lighter. If an area seems stubborn, run your finger over it to see if there is a divot. As long as there is no noticeable dip, it should be fine. Otherwise, keep sanding until the surface is even to the touch.

3 When sanding delicate and fragile areas like this tail, be certain that you firmly support the opposite side of where you are sanding. This will ensure that the piece does not snap off when you apply pressure with the sandpaper.

4 Complete the sanding. There will be a visible change in the evenness of the surface and with a few of the darker gray spots left. These spots don't have a tactile difference in surface quality, so the surface of the leg is now pretty even.

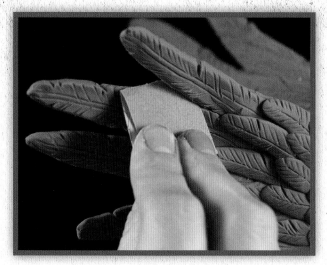

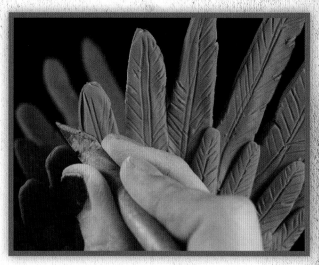

5 Folding a piece of sandpaper in half is a great way to get into tight spots like the spaces between these feathers. When sanding along edges like this, you can work with linear strokes of the sandpaper rather than circular ones.

6 I like to use my craft knife on areas that need a bit more push than the sandpaper can initially give. Here, I am cleaning up a seam I missed when smoothing out the clay prior to baking. Once I scrape away the excess clay, I sand it to smooth out the surface.

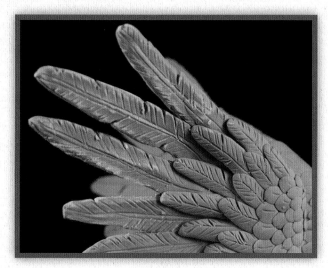

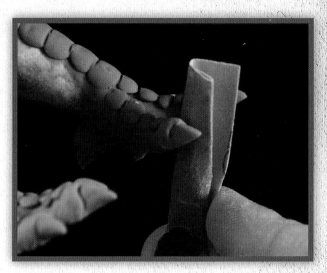

7 Areas with high amounts of texture don't need too much sanding lest you remove all the detail you sculpted. I like to do a dusting with the sandpaper, quickly and gently passing over the surface, only removing the topmost particles. This helps clean up any remaining imperfections in the texture while retaining all the fine details.

8 For fingers and toes, I often fold the sandpaper in on itself several times and run it along the edges of the digits. I also sometimes roll the sandpaper into a tight tube and use it in a similar manner. Additionally, you can wrap the sandpaper around a sculpting tool and use that to reach the areas needed.

FIELD NOTE

Once you have finished sanding your sculpture, use a soft, dry, clean paintbrush to gently brush over the surface of the sculpture. This will remove any dust remaining from the sanding process. It will also ensure that your sculpture will retain a smooth surface during priming.

SANDPAPER TIPS

1. Stick to 220 grit or finer when it comes to sandpaper. If you go too coarse, the surface of your sculpture can get scratched up. 3M makes a great sandpaper that has a tacky backing, making it easier to hold onto during sanding. (I have a photo of it in the Materials and Tools section.)

2. Precut your sandpaper into a variety of sizes. You will want some large pieces for broad areas and small pieces to get into small crevices.

3. Have your craft knife at the ready with a sharp blade newly installed. You will need this for stubborn bits of clay that don't respond to the sanding. It will also be used to crisp up edges.

4. Be gentle and work slowly with your sanding. You want to enhance the surface quality, but care must be taken to not destroy all the wonderful detail you have worked so hard to create. Pay close attention to how the surfaces flow on your sculpture and follow them carefully with the sandpaper.

5. Most of the time, you will want to sand in a circular direction to avoid leaving any streak marks.

6. If you are sensitive to dust, wear a dust mask while sanding. Apoxie Sculpt in particular creates a very fine powder when sanding that can be rather irritating.

7. Sculpey and Apoxie Sculpt both eat sandpaper alive! You will go through it rather quickly. Be sure to switch out pieces fairly often or you will be sanding your piece with not much more than a piece of paper after a while.

8. Tools like sanding sticks and sanding pads are a great help. Check out your local hobby shop to see the variety of sanding tools available.

SANDING REPAIRS

When sanding, you may discover errors in your sculpture that you overlooked before baking. Or you may have divots that couldn't be sanded down. These areas can easily be fixed through the use of Apoxie Sculpt. This clay adheres wonderfully to Sculpey. When used with water, Apoxie easily works its way into cracks, spaces and divots.

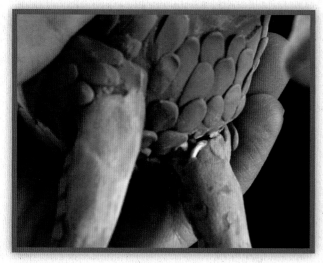

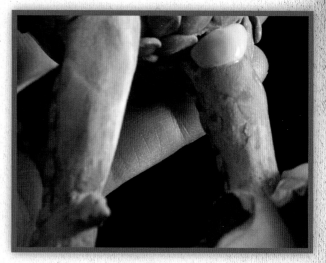

1 Locate a gap area. Here, I realized that I neglected to notice this gap around the elbow of the hippogryph where the armature is showing through the clay.

2 After I mixed together a small amount of Apoxie Sculpt, I press it into the gap. I keep my hands wet with water while doing this so my fingers don't stick to the clay. It also helps to keep a smooth surface on the Apoxie.

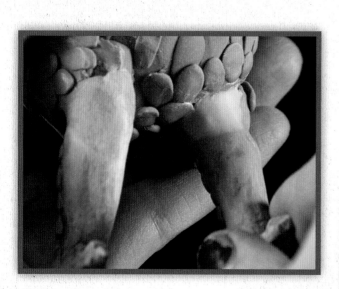

3 After applying the clay, I wet my hands and smooth the clay into place. The clay is worked until it is at an even level with the surrounding area. A rubber tool can be used in tight areas; just be sure to wet it first. Once Apoxie is dry, it can be sanded to form a smooth, level surface that is congruent with the rest of the piece. No one will ever know that annoying imperfection was there!

FIELD NOTE

Sometimes during the baking or sanding of a piece or even after a piece is painted, cracks or breaks will happen. These can be easily fixed using the methods mentioned on the previous pages.

USING SPRAY PRIMER

Primer helps even out the surface of the clay and readies your sculpture for painting. While you can paint directly on the surface of baked Sculpey, the paint will chip more easily as it won't adhere fully. I use PlastiKote sandable primer in the gray variety. I have found this to be the fastest-drying primer, and it leaves a great surface for painting. Make sure to read the instructions on the side of the can in *full* before using the primer no matter what brand you are using, and *always* use spray primer in a well-ventilated area, preferably outdoors if possible.

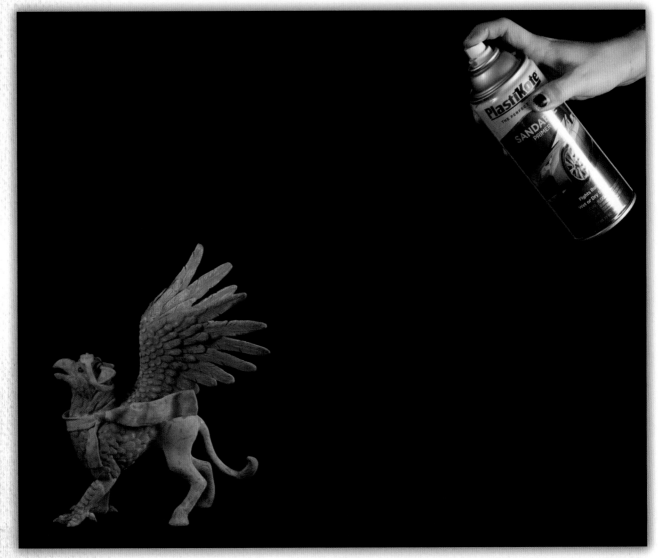

1 Place the sculpture on a sturdy surface covered with several layers of newspaper.

2 Thoroughly shake the can of primer and spray a light coat onto the sculpture, holding the can about 12" (30cm) away from the sculpture. If you get too close to the sculpture, the primer will apply too thick and may become tacky. Keep moving around the sculpture as you spray.

3 Allow the primer to dry and then add another layer. Repeat this for a third layer and allow to dry completely before touching.

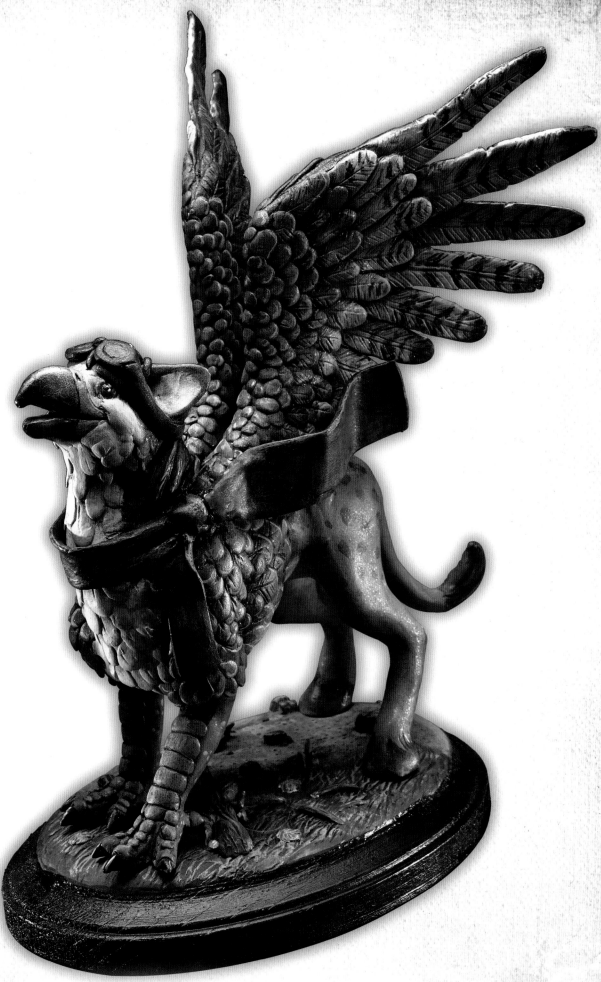

Visit **www.impact-books.com/fantasy-creatures-in-clay** for more amazing bonus features!

131

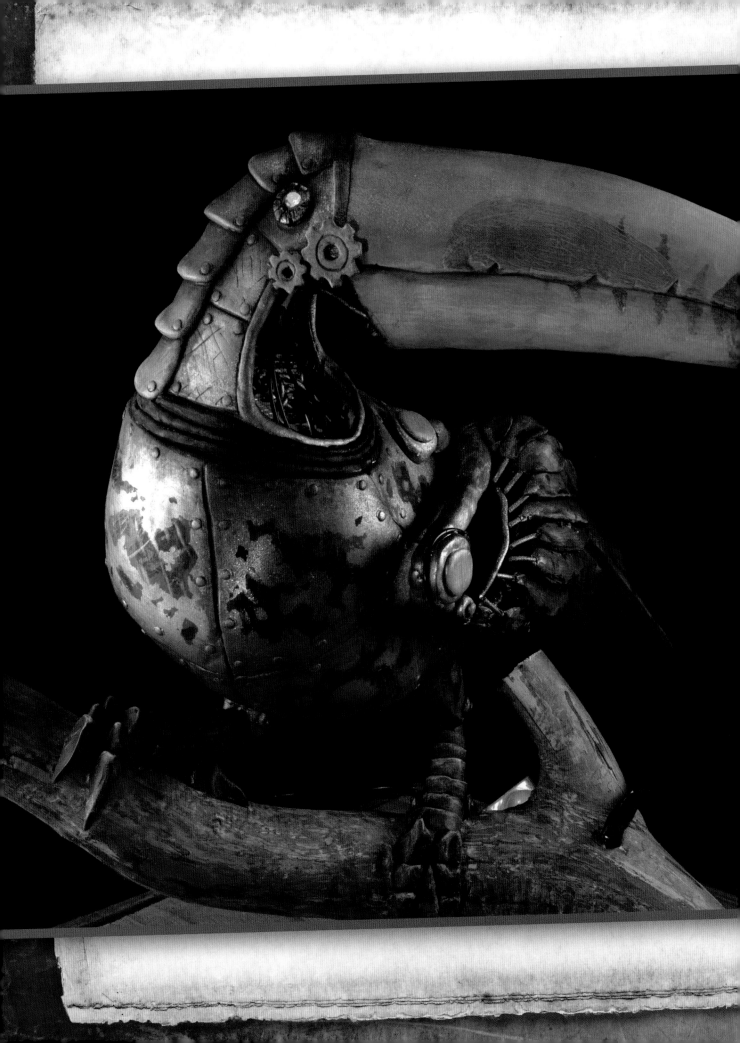

PAINTING AND FINAL TOUCHES

Painting a sculpture is much different from painting a two-dimensional image. Not only do you have surface quality to worry about, you also have to make sure it looks good from multiple angles. In order to keep consistency in the paint job, I always paint the whole sculpture in stages versus painting the leg full finished, moving on to the head and finishing it, etc. In other words, I paint in the same fashion that I sculpt and I always use 100 percent acrylics.

Painting is another one of those topics that I could write a whole book on. Unfortunately, we have limited space in this book so I have chosen a few topics that you will find most useful when painting a sculpture. However, I encourage you to do some research outside of this book. Reading up on basic color theory will help improve your paint jobs so much. Every artist should be armed with the knowledge of color schemes, the color wheel and how to mix colors. This chapter assumes that you have such basic working knowledge. If you are a beginner, there are a lot of amazing books on the subject of color theory that you can check out. There is also a lot of free information available online through a simple Google search.

In this chapter, we will begin by slowly building up a basecoat of paint. From there, we will start adding secondary colors and learn how to use a few blending methods to create gradients. Next, we will start working with different shading methods and start painting some details. I will also discuss a few finishing methods that will help add some nice qualities to your sculpture.

Painting Techniques

The first step in painting is laying down a good basecoat. A basecoat should cover the entirety of the sculpture and should reflect the most prominent color in the character. It is crucial that you build up this foundation slowly with thin layers of paint. This will ensure that your textures remain intact and any smooth surfaces remain as such.

∾ DEMONSTRATION

PAINTING A SOLID BASECOAT

1 Mix at least three colors together to apply on your character. Never use a color straight out of the bottle. Most of these colors are very saturated and unnatural looking. They do not exist in the natural world. Mixing your own colors will make your paint jobs look more realistic.

2 I like to use a large round-tipped brush to apply the basecoat. These brushes easily glide over the surface of the piece and can also work into cracks and crevices. I first dip my brush into water and then the paint. This thins out the paint for ease in application. I then apply the paint to the sculpture, using small overlapping strokes. I move the paint around the sculpture, keeping it smooth and even.

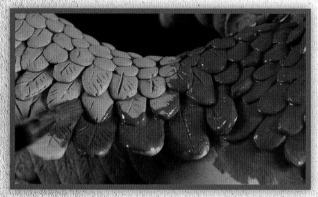

3 Be sure to cover every little spot of your sculpture with the basecoat. For areas like these feathers, the brush is pushed in between the seams to ensure even paint coverage.

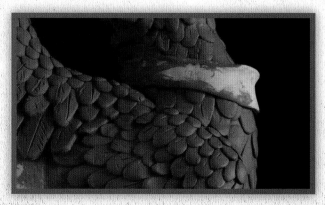

4 Let the first layer of the basecoat dry, then repeat the steps with the second and third layer. Making sure to let each layer dry completely before adding the next layer.

WET-ON-DRY METHOD

Now that the main colors have been laid down, it's time to paint the secondary colors (not to be confused with the secondary colors orange, purple and green!). These are large blocks of color that take up significant areas of the sculpture. Examples are the underbelly, primary feathers and manes. While some secondary colors can be painted flat onto the sculpture in the same manner as the basecoat, others need to be blended in. I will discuss several methods of blending paint.

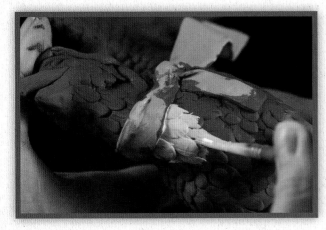

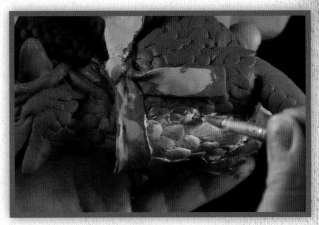

1 Apply a lighter color to the underbelly of the hippogryph. Once the color is applied to the desired area, I quickly rinse my brush. With the brush still wet, I brush over the edges of the wet color I just applied, blending it into the basecoat.

2 The brush will need to be repeatedly dipped back in the water to keep the blending clean. It is important to work quickly so the paint doesn't dry. This requires several layers of paint, each being blended into the last to form a smooth gradient.

WET-ON-WET METHOD

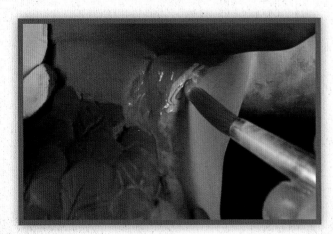

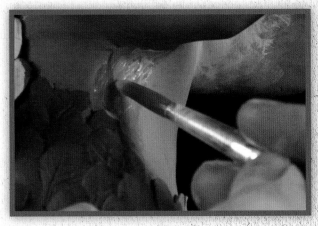

1 Brush one color onto the surface of the sculpture immediately followed by the second. Mix the colors while still wet.

2 Work back and forth between the two colors, rinsing the brush as needed. As with the wet-on-dry method, several layers may be necessary in order to achieve a smooth gradient between the two colors.

Visit **www.impact-books.com/fantasy-creatures-in-clay** for more amazing bonus features!

135

DRYBRUSH

This is generally used for painting highlights. The brush is dipped in a light-colored paint and then brushed back and forth over a paper towel to remove almost all the paint. The brush is then lightly brushed over the surface of the sculpture. Only the highest parts of the surface of the sculpture will pick up the paint, while the lower areas appear untouched. This will give the illusion of highlights. This technique works best on a textured sculpture but also works on a smooth piece.

 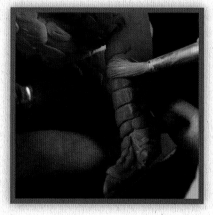 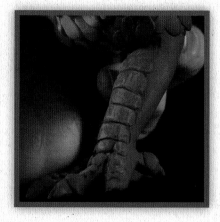

WASH

This is generally used for painting shadows. A dark color is watered down and brushed over the surface of the sculpture. Since the paint is watered down, it will easily work its way into the cracks and crevices of the sculpture. After the paint has been applied, the surface of the sculpture is immediately wiped down with a clean, dry paper towel. This will remove most of the paint from the higher points of the sculpture while leaving the deeper parts untouched. As with drybrushing, this works best on a textured sculpture.

PAINTING A BASE WITH DEPTH

Looking at the progression of this base, you can see the full drybrush and wash process in action. This is the basic process I use when painting most of my sculptures. Additional drybrush passes and washes can be used for even further added depth.

1 A basecoat has been applied to each item and is allowed to dry all the way.

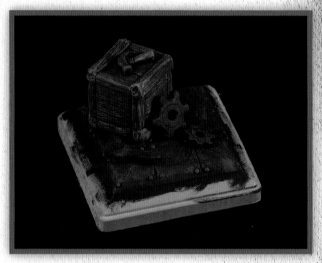

2 Each item is drybrushed separately, using a lighter color. For each one, I added a little white to the basecoat color and that was used for drybrushing.

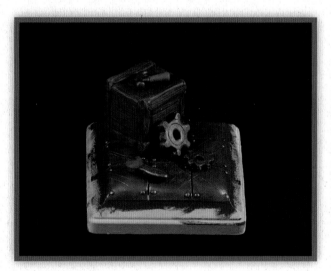

3 The first wash is now applied, using a very dark brown. The wash is wiped off, leaving the paint in the crevices of the sculpture. After the wash is completely dry, a second drybrush is applied, this time using some metallic paint to add texture.

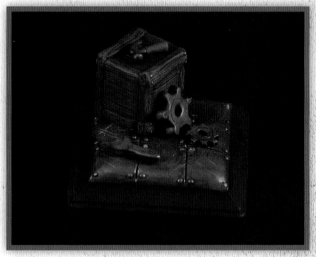

4 Final details like the nails on the box and the rim of the base are now painted on. I also like to go back and touch up areas of the drybrush and wash that need a little attention.

COMPLEX SCALE TEXTURE

The following shows how dry brushing and washes can be used on a complex scale texture.

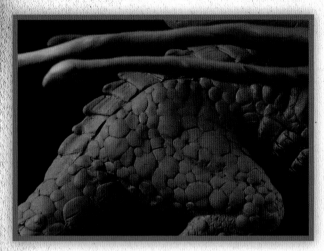

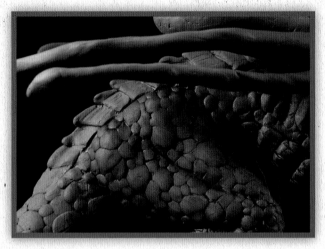

1 Above is an image of the scaled leg that will be painted. It has already been painted with a flat basecoat. To create the colors I need for drybrushing and washing, I simply take the base color and add to it.

2 The image shows the leg after the initial wash has dried. The dark color was watered down and brushed over the leg. The paint was worked into the seams between the scales. A paper towel was then rubbed over the surface to remove the excess paint sitting atop the scales. Already much more depth has been added compared to the first image.

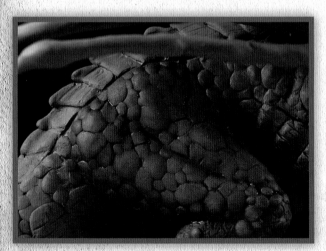

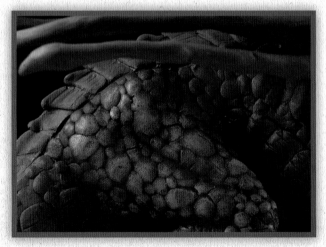

3 An initial drybrush is applied over the leg once the wash layer has dried. The change is subtle. Often, drybrushing will take several stages before the highlights approach the correct value. It is also important to strategically place the drybrush strokes so the higher points get more passes with the brush to give the illusion of a brighter highlight.

4 Using more than one color when drybrushing will add another level of depth. The scales still looked a bit flat after the initial drybrush, and I wanted to give the feeling of iridescence to them. I used a blue color and drybrushed the scales yet again, this time avoiding scales around the muscle definition lines to help those areas look deeper and darker.

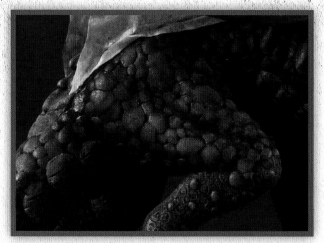

FIELD NOTE

Painting in layers is essential! Working with a number of thin layers of paint may take a long time, but it will add more depth and realism to your piece. Simply glopping on paint right out of the tube or bottle will result in a plastic and unnatural look.

5 I felt that the blue highlights looked a bit too prominent. I brushed a wash of the initial basecoat color over the top of the whole leg to unify the colors. Once that was dry, I went back to my first drybrush color and brushed on a few final highlights.

Visit **www.impact-books.com/fantasy-creatures-in-clay** for more amazing bonus features!

139

USING WASHES TO CREATE "SHADOWS"

In addition to defining textures, washes can be used to add shadows or darker areas to a piece. You aren't painting an actual light source but instead are painting areas that are inherently darker. This usually occurs at overlaps or crevices.

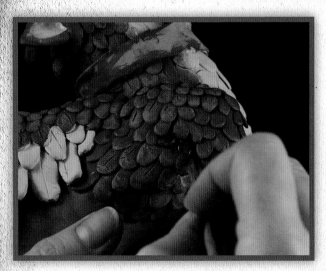

1 Here, I use a darker, watered-down shade of the base color to define the shoulder and armpit area. I start at the deepest point and work outwards with the paint.

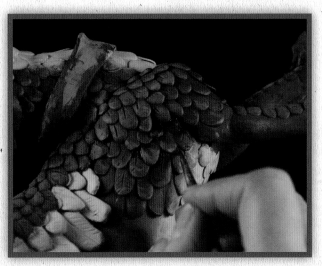

2 I use the same color to add some small shadows to the individual body feathers. Notice these washes are more controlled than the all over washes seen previously. These washes are applied in a similar manner as the secondary colors seen earlier.

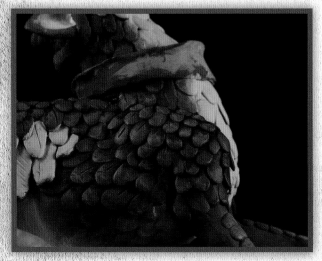

3 The image shows the dried washes that were applied to the feathers. Notice the depth that has been added when compared to the image for the first step on this page.

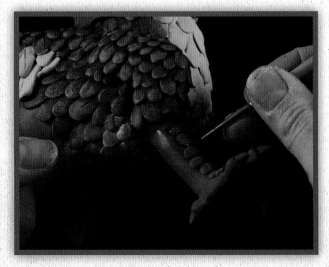

4 Washes can also be applied with a thin brush to define fine lines such as the crevices between the scales. Using a wash will look much more natural than applying thick paint to delicate details such as this.

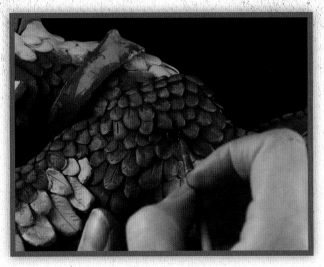

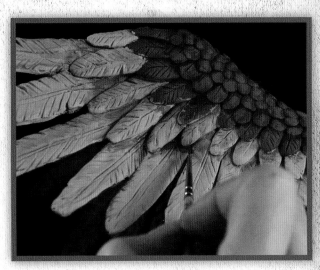

5 There may be areas of your piece that need to be pushed a shade or two darker. Often, using a shade of that particular color just won't do. Here, I am using a deep purple to help add a final bit of depth to the armpit area.

6 I also add some purple to the primaries. Notice the difference between the existing shadows (a darker brown) vs. the purple shadow being applied. Using complementary colors in your shadows is a great way to add depth to your textures.

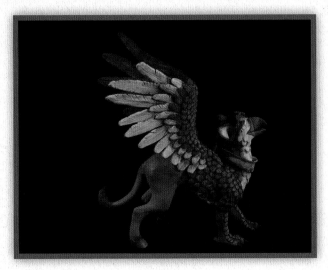

7 Shadows have been added to most of the feathers and around areas of overlap. This includes where the jaw overlaps the neck, where the feathers of the elbow cover the scaled arm, and where the feathered torso transitions to the rear legs of the horse.

Visit **www.impact-books.com/fantasy-creatures-in-clay** for more amazing bonus features!

141

PAINTING DETAILS

The next few pages explain a few techniques I use when painting details. This is another one of those expansive subjects on which I could write a whole book. How- ever, I picked the things I thought would be the most helpful to see and those that are easily applied to other aspects of detailing.

∿ DEMONSTRATION

SPOTS

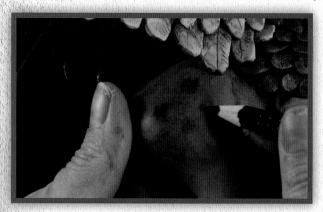

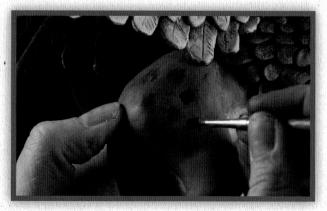

1 Patterns like spots or stripes can be first drawn on the surface of the sculpture using a watercolor pencil. These pencils will stick to the acrylic paints but will also wash off easily with water if you make a mistake. This is a great way to lay out your texture before jumping into acrylics, which are not erasable.

2 The appropriate color is brushed on and blended with the watercolor pencil using a fine-detail brush. I like to keep the edges of the spots a bit feathered because hard edges will make them look drawn on.

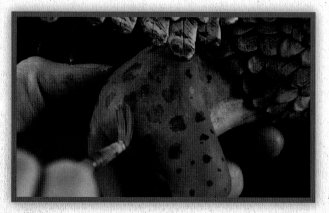

3 The finished spots get smaller as they move down the leg towards the foot.

4 The spots are looking rather dark and uniform right now. A light wash of the basecoat is brushed over the spots. This adds some variety in value to the spots as well as ties them in with the rest of the leg.

FEATHER MARKINGS

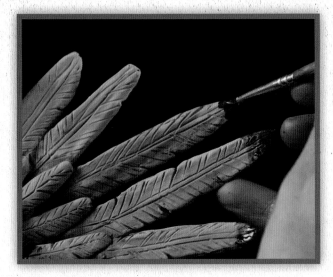

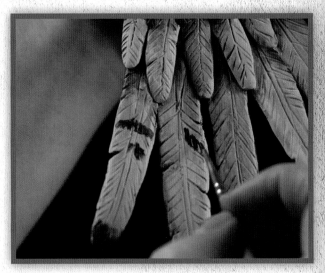

1 Feathers often have dark tips. Here, I am adding some dark brown tips to the ventral side of the primaries. I first add the dark paint to the feather and then blend it in with water.

2 Barring is also commonly seen on flight feathers. Using small parallel strokes, I follow the diagonal flow of the barbs with my paintbrush, creating the barred pattern. The bars should be smaller and fewer as the feathers get smaller.

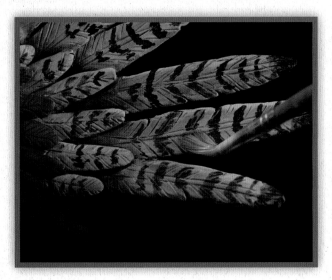

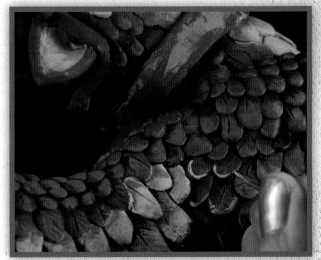

3 As with the spots, the barring is blended in with the rest of the wing only this time using drybrush instead of a wash. This breaks up the monotony of the pattern by adding variety in value.

4 Light tips are added to the body feathers. These tips vary in brightness and thickness depending on the size of the feather. The color used here is the same color that the ventral wing feathers carry.

ACCESSORIES

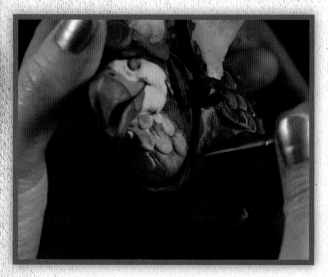

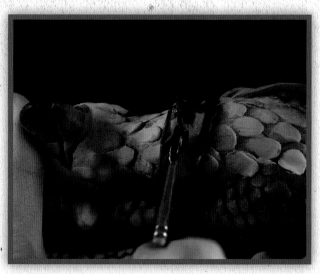

1 For accessories, I first paint a thin line along the edge that meets the body. I want to ensure that this line stays clean before filling in the rest with paint. This is demonstrated on the scarf in the photo above as well as the goggles.

2 The rest of the scarf is now filled in with a larger brush without having to worry about the edges getting messy. Washes and/or drybrushing can now be added to the accessory.

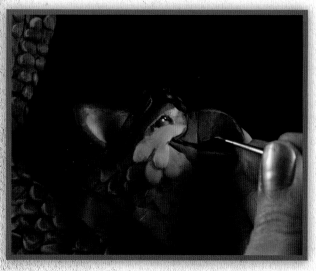

FIELD NOTE

It is very important not to overdetail a sculpture. It is easy to get so swept up in creating details that you forget to look at the big picture. Take a step back from time to time and add detail only as needed. Many times, less is more.

3 Fine details such as these highlights on the beak can be added to smooth surfaces to enhance their appearance and add points of interest.

EYES

Eyes are among the last things I paint. This way, I don't mess them up while painting the rest of the sculpture.

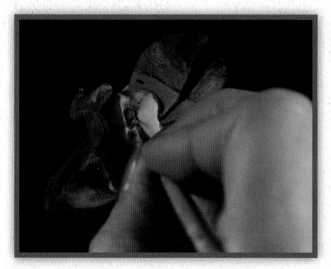

1 I paint the color of the iris. Sometimes I add a highlight and shadow if the figure is large enough, but this is not the case here.

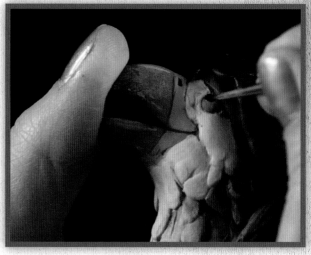

2 I add the pupils. I do not use pure black but instead a very dark version of the base color (80–90 percent black to 10–20 percent base color).

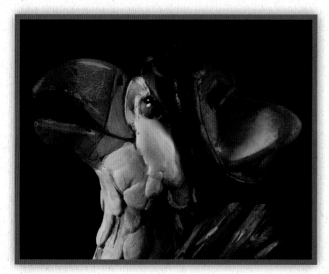

3 I dot the eyes with two highlights. Once again, I do not use pure white for these highlights. They have about a 10 percent mix of the base color added to them so they don't look too stark. That goes for scleras as well if your character has them visible.

FIELD NOTE

Make sure the pupil placement is accurate to the direction in which you want the eyes looking. If you are having difficulties with placement, try using a white watercolor pencil to figure out pupil placement prior to painting. You can wipe away the markings with a damp cloth and redraw them until they are correct.

CREATING TRANSLUCENT WINGS

In addition to creating wings 100 percent from clay, I often use another method. This method is especially effective for translucent wings but can be used for opaque wings as well. This method uses glassine, a special paper that can be purchased at most specialty art stores. You will also need Mod Podge, a decoupage finish; slightly watered down Elmer's Glue All can be used as an emergency replacement.

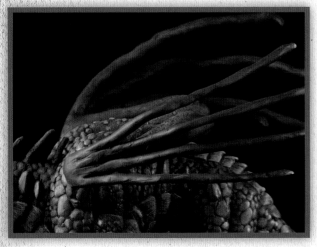

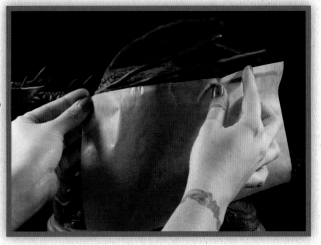

1 Your sculpture *must* be baked before applying the glassine. Never put glassine in the oven. If you want the wings to remain translucent, I recommend painting the sculpture prior to glassine application, lest you get paint all over the glassine.

2 Lay a piece of glassine over the first two wing fingers that you want the membrane to stretch over. Get a rough estimate of how much paper you will need for the segment, allow a good ¼" (6mm) of excess around the whole thing.

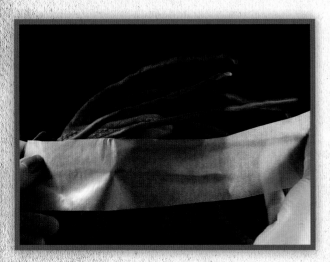

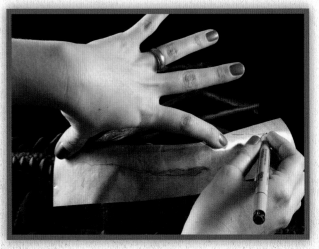

3 Using scissors, cut down the piece of glassine according to your measurement. This will create a more easily workable area.

4 Keeping the paper held in place over the wing fingers with one hand, trace the shape of the wing fingers onto the paper. You will want to leave some extra space around the whole thing; this will allow you to attach the membrane to the wing without running out of paper.

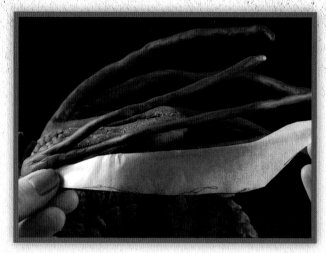

5 Cut out the segment using scissors. Double check it against the wing to make sure it fits in place properly, covering the wing fingers along the entire length.

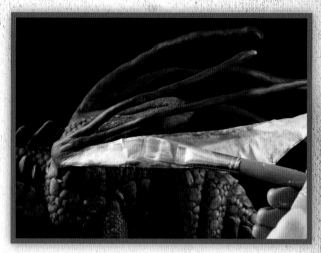

6 Brush Mod Podge onto the segment until it ceases to curl and becomes flexible. Don't overdo it or the paper can tear. Place the segment onto the wing, making sure all edges of the glassine overlap the clay. Smooth it into place using your paintbrush. Wrap the edges around the fingers. You can either let this air dry or use a hair dryer on the low setting to speed up the drying. Make sure to wave the hair dryer and keep about a foot (30cm) of space between the hair dryer and the sculpture.

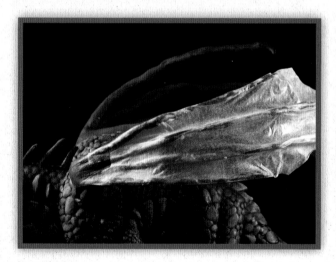

7 Repeat these steps for each segment of the wing, making sure not to overlap the segments. Notice how stretch lines appear naturally when the Mod Podge dries. This is a great effect that you can really use to your advantage.

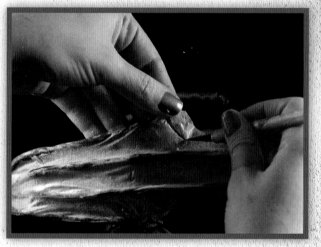

8 When the wing is fully dried, you can clean up the edges of the wing membranes using a craft knife. Make sure to use a fresh, sharp blade and work slowly and carefully. Mod Podge gives a sort of elasticity to the glassine, so it makes it more tear resistant than it normally would be.

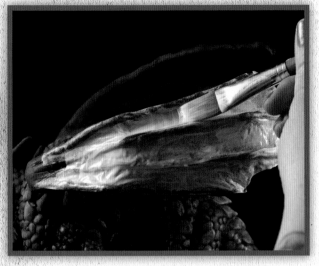

9 Apply two more coats of Mod Podge, allowing each layer to dry completely before applying the next. This will add even more strength to the membranes.

10 Once the Mod Podge is fully dried, you can sand down the seams created by the glassine on the wing fingers. Use light pressure so the wing finger doesn't snap. A 220 grit sandpaper is perfect for this job. You can go even finer if you need a smoother finish.

11 Finally, the wing fingers can be repainted to match the colors of the sculpture. Use a fine-tipped brush here and take special care not to get any paint on the glassine. You may also want to add some character to the wings by adding holes or tears using the craft knife as I did here.

12 Shown above are the final wings. The glassine was given a very light wash of purple to help it tie in with the rest of the sculpture and to accentuate the wrinkles and folds. I also added a light dusting of an iridescent Pearl Ex powder to help define the highlights just a touch. You may also wish to treat the glassine like the rest of the sculpture and paint it with opaque colors. Just be sure not to use too much heavy paint or it could cause the glassine to become soggy. If the glassine is still slightly tacky to the touch, you can use a brush-on or spray-on sealant to remove the tackiness.

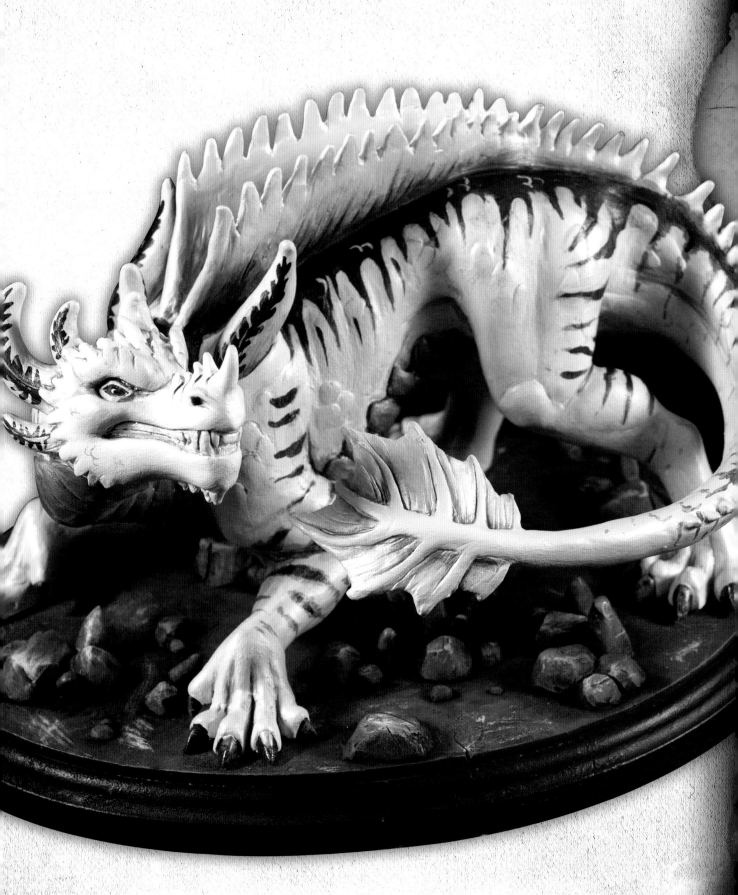

Visit **www.impact-books.com/fantasy-creatures-in-clay** for more amazing bonus features!

149

ADDITIONAL FINISHES

～ DEMONSTRATION

FAUX METAL

Perhaps instead of painting a figure in full detail, you would like to give your sculpture a metallic finish. This is quick and easy to do as it requires only several layers of acrylic paint. Using a faux finish is a wonderful way to make your sculpture look good quickly.

1 I will create a faux bronze finish for my sea horse sculpture. The basecoat is a very dark brown. I added the brown seen in the right compartment of the palette to the black shown in the center to create the basecoat color.

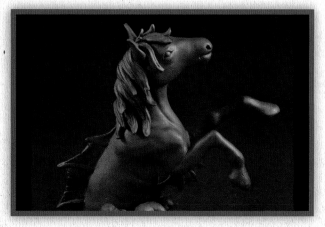

2 The basecoat has been applied to the sculpture. Notice the black appears warm and natural. This will help bring out the warm tones of the bronze. Using straight black would not yield the same result.

3 Using the drybrush method, metallic gold paint is brushed over the entire surface of the sculpture. The highest areas of the sculpture will grab the gold paint while the crevices will remain dark.

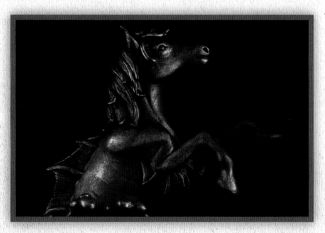

4 With just a few passes of the gold drybrushing, the finish is already looking pretty great. However, it looks a bit too even and perfect. Unless they are right off the line, metal sculptures have some sort of tarnish or wear on the surface.

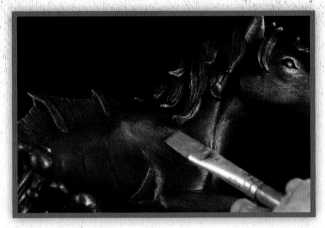

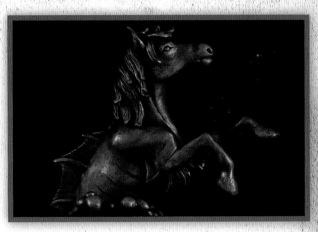

5 Areas of warm gray are drybrushed atop the very highest points of the sculpture. These are areas that would be the most susceptible to wear and damage.

6 The image shows the sculpture after various areas have been hit with the gray. Notice I didn't go overboard with it but instead just added hints. Going too heavy would result in the same uniform look we started with.

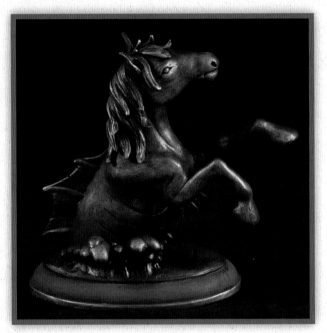

FIELD NOTE

This technique can be used for other finishes as well. For silver, add blue or purple to the basecoat instead of brown.
For copper, use green.

7 Another layer of gold is drybrushed over the sculpture to blend in the gray. The difference is subtle, but there is now a bit more variety in the surface of the piece. The base was painted with the same brown used to tint the basecoat. A gold rim was added using the same color used for drybrushing.

PEARL EX

Pearl Ex is a wonderful product that can be used to add hints of sparkle, sheen or iridescence to an area on your piece. It comes in powder form in a large variety of colors and finishes. The Interference powders work great on black.

1 I use Interference Blue here to add a bit of a blue sheen to the lens on the hippogryph's goggles. I first dip a clean, dry brush into the powder, tapping off the excess on the rim of the jar.

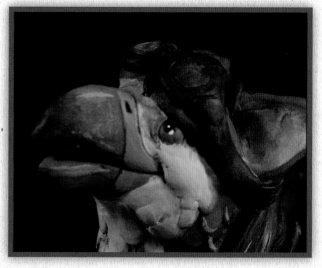

2 The powder is then carefully applied to the desired area. Alternately, you can dip your finger in the powder and spread it across the sculpture, which I often do on larger areas.

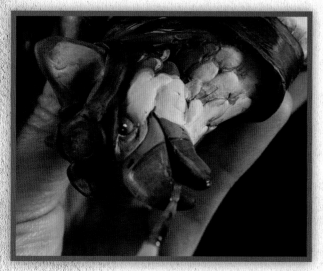

3 Pearl Ex can also be mixed with clear brush-on varnishes and applied to the piece with a brush. This seals the Pearl Ex in wonderfully but can be used only on areas that will be glossy or shiny. Even matte brush-on varnishes carry a certain amount of gloss to them.

VARNISHES

Spray varnish will help seal your paint and Pearl Ex to the sculpture. It will help prevent paint chips too. I use Krylon's matte finish spray on just about all of my pieces. The process for spraying varnish is very similar to that of spraying primer. It is essential that you do not spray too close to the piece as it will cause the varnish to become thick and sticky, ruining all the hard work you put into your paint job.

1 Place the sculpture on a sturdy surface covered with several layers of newspaper.

2 Thoroughly shake the can of varnish and spray a light coat onto the sculpture, holding the can about 12" (30cm) away from the sculpture. Keep moving around the sculpture as you spray.

3 Allow the varnish to dry and then add another layer. Repeat this for a third layer and allow it to dry completely before touching.

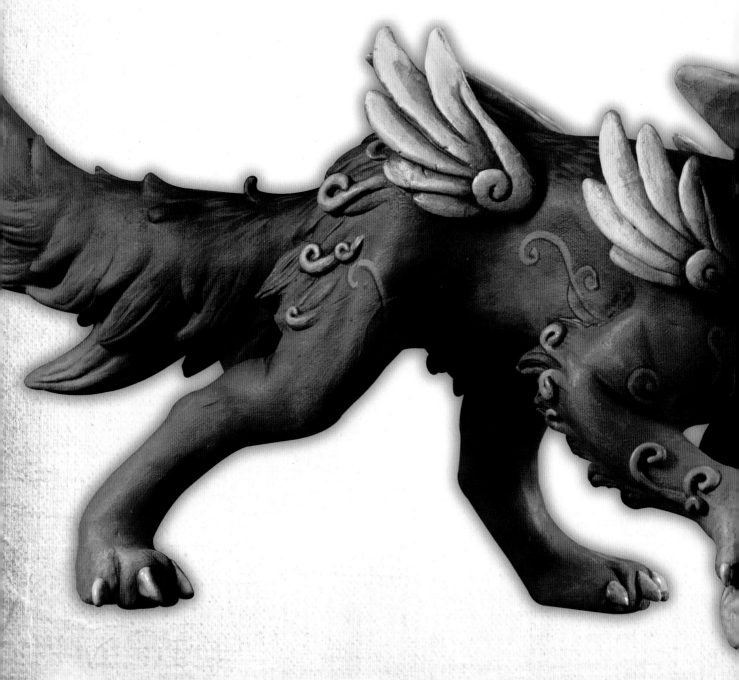

INDEX

Other fine IMPACT Books are available from your favorite bookstore, art supply store or online supplier. Visit our website at fwmedia.com.

18 17 16 15 14 5 4 3 2 1

DISTRIBUTED IN CANADA BY FRASER DIRECT
100 Armstrong Avenue
Georgetown, ON, Canada L7G 5S4
Tel: (905) 877-4411

DISTRIBUTED IN THE U.K. AND EUROPE
BY F&W MEDIA INTERNATIONAL LTD
Brunel House, Forde Close, Newton Abbot, TQ12 4PU, UK
Tel: (+44) 1626 323200, Fax: (+44) 1626 323319
Email: enquiries@fwmedia.com

DISTRIBUTED IN AUSTRALIA BY CAPRICORN LINK
P.O. Box 704, S. Windsor NSW, 2756 Australia
Tel: (02) 4560-1600; Fax: (02) 4577 5288
Email: books@capricornlink.com.au

ISBN 13: 978-1-4403-3672-0

CHARACTER CREATION CREDITS:
Flora, Christy Shao, 106–107; *Fiery Foo Dog,* Lee Duckworth, 154–155; *Sirion,* Linda Lundqvist, 155; *Warrior Tapir,* Nora O'Connor, webspace.ringling.edu/~noconnor, 158; *Kiva,* P. Anastasia, mightynovelist.com, 149

Edited by
BRITTANY VANSNEPSON

Designed by
HANNAH BAILEY

Photography by
JOE COLEMAN

Production coordinated by
MARK GRIFFIN

METRIC CONVERSION CHART

TO CONVERT	TO	MULTIPLY BY
Inches	Centimeters	2.54
Centimeters	Inches	0.4
Feet	Centimeters	30.5
Centimeters	Feet	0.03
Yards	Meters	0.9
Meters	Yards	1.1

ABOUT THE AUTHOR

Emily is a freelance sculptor who has been sculpting since 2001. She has always had a love for fantastic creatures and draws most of her inspiration from wildlife and nature. She very much enjoys designing her own creatures, from concept to finished sculpture.

For the most part, Emily is a self-taught artist, learning much of what she knows through observation, anatomy books, and lots of experimentation. She taught college level art for over five years, specializing in sculpture. She enjoys combining her artistic skills with her passion for teaching to help beginning artists get on their path.

ACKNOWLEDGMENTS

My original team of editors, Jeremy Beck, Jessica Dunbar, Ashley Gaia and Sharon Rigelsky. You helped form this book into what it is today!

Holly Earhart and the entire Art Department staff at Full Sail University. You guys taught me to teach and always believed in me even when I didn't believe in myself.

Scott Fensterer, Tom and Joy Snyder, The Shiflett Brothers, Melita Curphy, and all my other fellow sculptors who have given me guidance and support in my career.

Polyform Products Company and Monster Makers, for making the amazing clays used in this book. A special thanks to Arnold Goldman, the creator of Monster Clay, for supporting this book.

All of my loyal readers who supported this book when it was *Creature Sculpt*. Without all your support and feedback, I never would have gotten this far.

All my friends and family who have shown me endless support over the years. I love you all!

DEDICATION

This book is dedicated to my parents. They have supported my artistic endeavors since I was a small child and have always encouraged me to create. I wouldn't be where I am today without them.

Also to my loving husband who not only has shown me endless support over the years, but was the extremely patient photographer for this book. He devoted many weekends and evenings helping me and has supported me throughout this book's creation.

IDEAS. INSTRUCTION. INSPIRATION.

Extra bonus features can be found at **www.impact-books.com/fantasy-creatures-in-clay.**

Check out these IMPACT titles at impact-books.com!

These and other fine **IMPACT** products are available at your local art & craft retailer, bookstore or online supplier. Visit our website at **impact-books.com.**

Follow **IMPACT** for the latest news, free wallpapers, free demos and chances to win FREE BOOKS!

FOLLOW US!

IMPACT-BOOKS.COM

- ∾ Connect with your favorite artists
- ∾ Get the latest in comic, fantasy and sci-fi art instruction, tips and techniques
- ∾ Be the first to get special deals on the products you need to improve your art